painting the
secretworld
of nature

john agnew

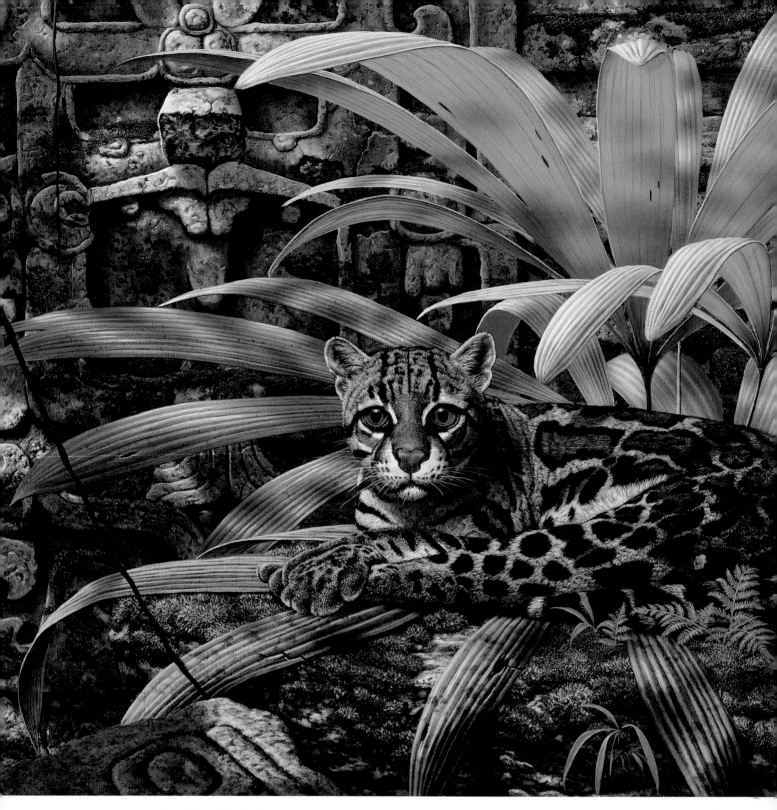

Guardian of the Gods
24" x 32" (61cm x 81cm)
Acrylic on canvas

painting the
secretworld
of nature

john agnew

NORTH LIGHT BOOKS
CINCINNATI, OHIO
www.artistsnetwork.com

about the author

John Agnew was born in 1952 in Dayton, Ohio. His early dreams of a career in herpetology gradually changed into a career as a museum artist, exhibit designer and scientific illustrator, and now as an award-winning fine artist specializing in natural history art.

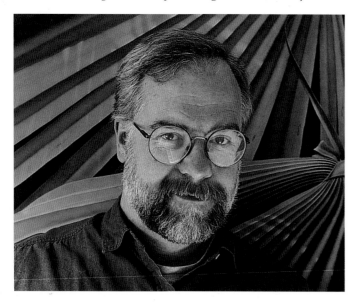

In his high school years John was privileged to work in the Exhibits Department of the Dayton Museum of Natural History. The museum experience molded his love of nature and science. He graduated in 1976 with a Fine Arts degree from the University of Cincinnati's College of Design, Art and Architecture. He worked as a curator in a Florida science museum a few years before going freelance, and for the last twenty years he has designed exhibits, painted murals and produced illustrations for museums and zoos around the country and as far away as Moscow. Since moving back to Cincinnati in the early 1980s, John has produced over twenty-thousand square feet (eighteen-hundred square meters) of murals and diorama paintings for the Cincinnati Zoo and the Cincinnati Museum of Natural History and Science.

He has traveled extensively in Central America and the Caribbean, providing the inspiration for many paintings of tropical wildlife. His travels in the U.S. have inspired his paintings of the deserts and southern wetlands. John has only recently pursued wildlife art in a serious way. In 1998 he was juried into the Society of Animal Artists, and his work has toured with their annual show ever since. He has also had works selected for the Arts for the Parks show, sponsored by the National Park Academy of the Arts, in 1998, 1999 and 2000.

Painting the Secret World of Nature. Copyright © 2001 by John Agnew. Manufactured in China. All rights reserved. No part of this book may be reproduced in any form or by any electronic or mechanical means including information storage and retrieval systems without permission in writing from the publisher, except by a reviewer, who may quote brief passages in a review. Published by North Light Books, an imprint of F&W Publications, Inc., 1507 Dana Avenue, Cincinnati, Ohio 45207. (800) 289-0963. First edition.

Other fine North Light Books are available from your local bookstore, art supply store or direct from the publisher.

05 04 03 02 01 5 4 3 2 1

Library of Congress Cataloging-in-Publication Data

Agnew, John.
 Painting the secret world of nature/by John Agnew.
 p. cm.
 Includes index.
 ISBN 1-58180-050-9 (alk. paper)
 1. Nature (Aesthetics) 2. Acrylic painting—Technique. I. Title.

ND1460.N38 A35 2001
751.4'26—dc21 00-069539
 CIP
Edited by Jennifer Lepore Kardux
Cover designed by Amber Traven
Interior designed by Matthew DeRhodes and Camillia Ideis
Interior layout: Tari Sasser
Production Coordinator: Kristen Heller

metric conversion chart

to convert	to	multiply by
Inches	Centimeters	2.54
Centimeters	Inches	0.4
Feet	Centimeters	30.5
Centimeters	Feet	0.03
Yards	Meters	0.9
Meters	Yards	1.1
Sq. Inches	Sq. Centimeters	6.45
Sq. Centimeters	Sq. Inches	0.16
Sq. Feet	Sq. Meters	0.09
Sq. Meters	Sq. Feet	10.8
Sq. Yards	Sq. Meters	0.8
Sq. Meters	Sq. Yards	1.2
Pounds	Kilograms	0.45
Kilograms	Pounds	2.2
Ounces	Grams	28.4
Grams	Ounces	0.04

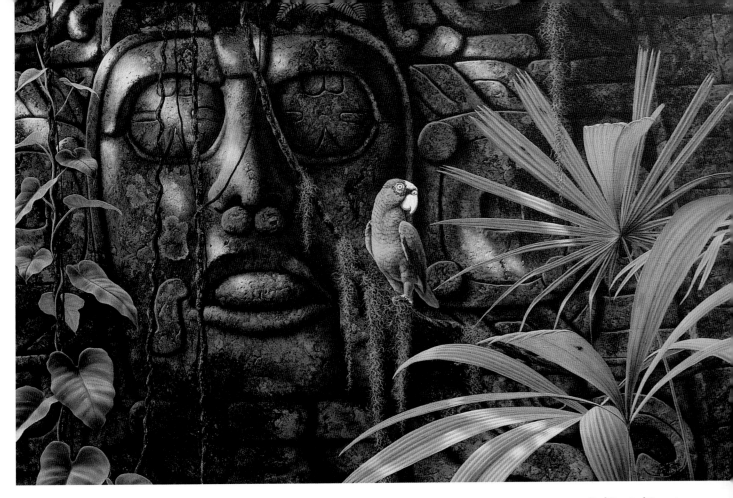

Red-Fronted Parrot
32" x 48"
(81cm x 122cm)
Acrylic

dedication

I dedicate this book to my wife, Pat, and to my daughter, Kate. They are my toughest critics and and my best fans.

acknowledgments

I want to thank my wife and daughter for their help and suggestions, which made this work possible. I also want to thank my mother, herself an artist, who made my career in art possible and who is a continuing inspiration.

My fellow artists of the Wildlife 2000 project, Devere Burt, Gary Denzler, Mark Eberhard, Charley Harper, Les LevFevere and John Ruthven, have provided encouragement and inspiration.

I also want to acknowledge the talent and patience of the North Light Books staff, particularly my editor, Jennifer Lepore Kardux. They have taken my words and pictures and turned them into a beautiful publication.

Evening Alligator
20" x 30" (51cm x 76cm)
Ink on paper
Collection of Devere Burt

table of contents

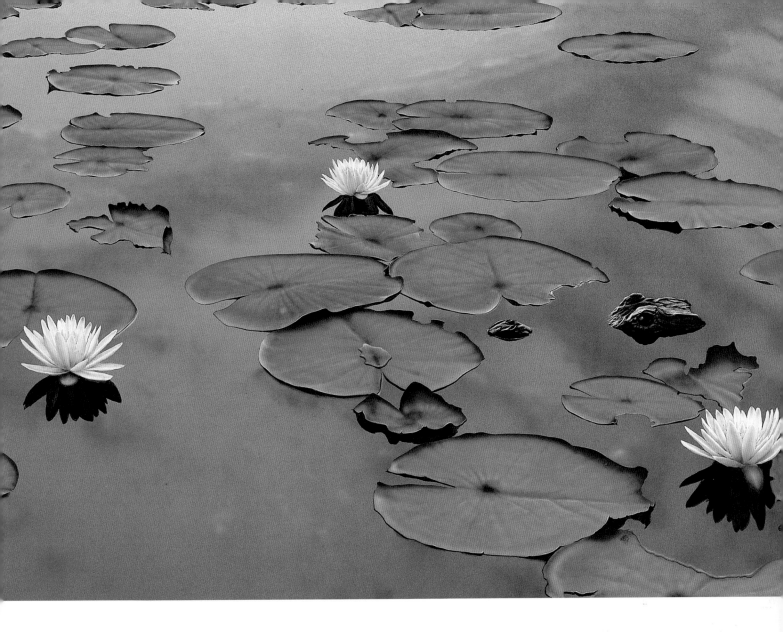

foreword

Clearly in his element, my friend John Agnew moves quietly through the dappled light of a Meso-American rainforest, searching for ocellated turkeys. Beaded sweat trickles down his face and the bridge of his nose, his glasses are steamed up, his clothing is wet from the humidity and the effort, while visions of the landscape, its vegetation and its turkeys become focused in his mind. This setting is an environment any citizen of the world's temperate regions would find uncomfortable, a place where venomous snakes, spiders as big as your fist and multitudes of biting and stinging arthropods lurk out there in the foliage just beyond your range of vision. Yet this is how a John Agnew painting typically begins, and the hunt in this darkly beautiful setting is just heaven to John. The tropics are one of his favorite places, and he paints these lush and biotically rich, yet hostile, settings better than anyone.

Two factors account for his artistic success—his establishment of an emotional connection, an intimate first-person experience with the subject or environment, and his great patience at the easel. The results are paintings capable of stopping viewers in their tracks!

John occasionally leaves the studio to paint on a gargantuan scale as a museum muralist, where his highly detailed paintings, spanning thousands of square feet, still invite close inspection and confound the viewer with their intricacies. Two locations in Cincinnati, Ohio, offer spectacular examples of John's immense murals: the natural history museum's "Ice Age" exhibit inside the Cincinnati Museum Center, and the Cincinnati Zoo's "Cat House" and "Jungle Trails" exhibits.

This book includes illustrated examples of John's paintings, as well as the methods and materials he uses to complete these works of art. The book provides an intimate opportunity to follow the genesis of a painting from the point of inspiration to completion, as it is being rendered by a very talented and accomplished wildlife artist.

Devere Burt
Director Emeritus
Cincinnati Museum of Natural History and Science

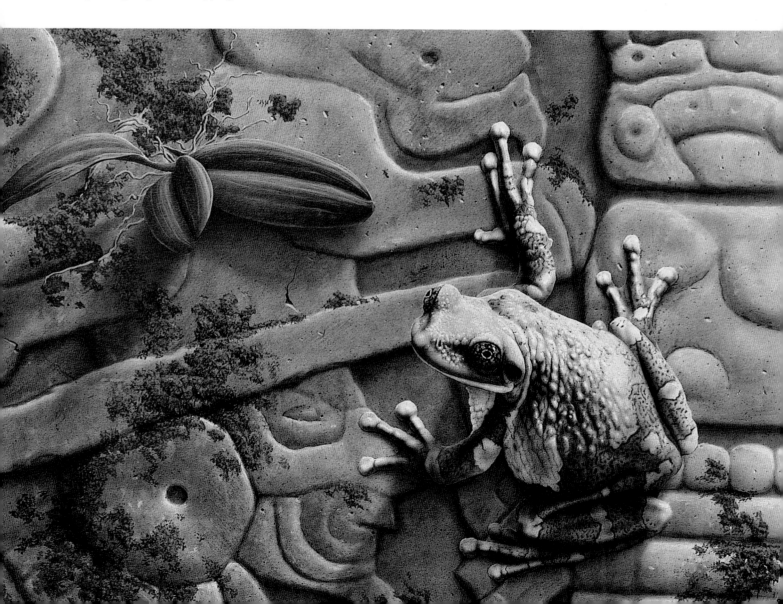

introduction

Since I was a youngster, I have been fascinated with reptiles. Like a lot of kids, it started with dinosaurs. I drew dinosaurs, and then lizards and snakes, every chance I got, never dreaming that I would get to do it as a professional one day. I guess I never grew out of my childhood dreams and fantasies. To this day I have a basement full of snakes and lizards, and I still draw and paint them, although my artistic interests have broadened a bit.

To find the creatures I love, I have had to search out some of the more obscure places in nature. This has led me to know and love lots of "secret" places and the creatures that inhabit them. I like the feelings of intimacy and possession that come with a personal discovery of a small corner of the natural world. Of course, most of these spots are not really secret at all. It's the setting that can lend an air of mystery and privacy that takes me back to the imagination of my childhood. It's wonderful to be able to share that through my paintings.

My skills as an artist developed along with my love for science, and the craft of museum exhibit builder gave me respect for detail and accuracy. Perhaps this is why I have always strived for a very realistic style. People sometimes ask, "Why not take a photograph?" As an illustrator, my reply is that photographs can't carry as much information as a painting. As an artist, my reply is that I want to have total control of the composition and lighting. Taking a good photo depends as much on luck as it does on skill and artistic sensibility. The best nature art combines accuracy and aesthetics to convey an expression of our rational thoughts and emotional feelings about our world. The result should be an emotional response from the viewer, followed by an appreciation of the information carried by the image. Knowledge of nature enhances our appreciation of it, and the information conveyed by nature art enhances our appreciation of both art and nature.

I hope that this book will help you develop the skills to convey your own messages about your experiences in nature. Each of us has something important to share, and I can't think of a better way to do it than through our art.

John Agnew

Mayan Tree Frog
15" x 20" (38cm x 51cm)
Acrylic

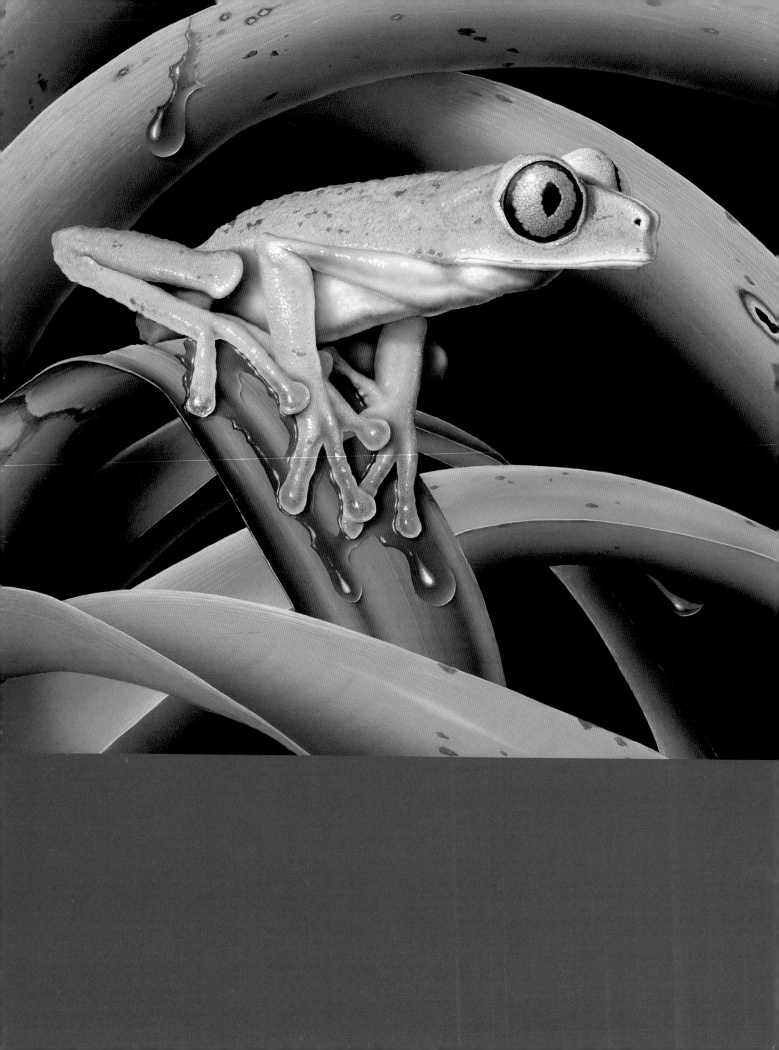

A Wet Night Out
15" x 20" (38cm x 51cm)
Acrylic on illustration board

chapter 1

getting started

Finding ideas and deciding how to start your painting are at the same time the easiest and the most difficult parts of the whole process of painting. I find that I do better if I don't try too hard. Go out into the world and enjoy, opening your mind along with your eyes. Take a camera, a sketchbook and your memory. It doesn't much matter where you go; let your interests lead you. If you want to find certain types of animals, take their habits into consideration and go where you can find them. If you don't already know how to find them, a little research or a trip with someone who does know will be necessary. Visit game farms or zoos to get close-ups of mammals or birds. Or just sally forth and let serendipity lead you to your next painting subject. The important part is to be prepared to capture your subject in some fashion.

collecting reference materials

photography

Working in great detail means gathering as much visual information as possible. Photography is an important tool for realist painters, but do not rely entirely on a photo to gather all of the information that you need. Photos can fool you, especially if the subject is not something with which you are intimately familiar. The shape of an animal's body can be distorted by a photograph, or the photo can show an animal in an unusual position or situation that won't translate well into a painting.

camera and lens

A 35mm camera with a 105mm macro lens will allow you to get good close-ups of creatures like lizards and insects from a distance that doesn't unduly alarm the subject. Try to carry a few additional lenses for other situations, such as wide-angle lens for landscapes or "skyscapes," or a good telephoto for bird or mammal photography.

sketches

A small sketchbook helps in the taking of visual notes and lets you do sketches in the field of interesting forms you find. Doing sketches in addition to photographs helps you gain a real understanding of the subject. Some people come to rely so much on photos that they hardly look with their own eyes. Doing a sketch forces you to really observe the subject and helps greatly with your interpretation of your photographs in the studio. Also, a camera is not useful in every situation because of lighting or other difficulties, so a sketchbook can help fill in the gaps.

Captivity Vs. Wild

When using your photos from zoos or game farms, be sure your animal is not overweight or showing other obvious signs of captivity. Trim nails or a clipped-back beak will make your subject appear out of place in the world of nature.

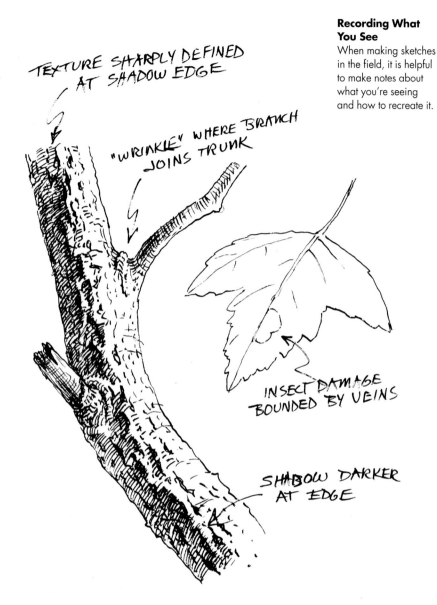

TEXTURE SHARPLY DEFINED AT SHADOW EDGE

"WRINKLE" WHERE BRANCH JOINS TRUNK

INSECT DAMAGE BOUNDED BY VEINS

SHADOW DARKER AT EDGE

Recording What You See
When making sketches in the field, it is helpful to make notes about what you're seeing and how to recreate it.

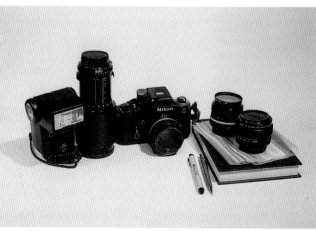

Photography Equipment
Here is the photography equipment I take with me into the field. From left to right: electronic strobe for close-ups, a macro-telephoto zoom lens, a 35mm camera with a normal lens (50mm), a wide-angle lens (28mm) and a macro tele-converter. Below the lenses are some plastic bags and a notebook for field notes and sketches.

props

When going out into nature in search of reference materials, take a few small plastic bags. Besides being available to protect your camera equipment in the event of rain, you can use them to collect props such as dead leaves or moss that may become an element of a painting. These props can then be used in the studio to set up a "still life" that will become a stage or backdrop for an animal, or just as a useful reference for detailed textures.

computer and video

Another way to collect reference images is through electronic imaging. The computer has become a nearly ubiquitous fixture in our homes, and many artists use them for office work or graphic design. The ability of computers to capture video images makes it possible to collect images of animals in motion in a way not possible just a few years ago. You can tape nature programs from the television, or you can take your video camera to the zoo or on your own safari and capture your subject animal in motion. You can find the exact pose you want by advancing the tape frame by frame, capturing the image on the computer, and printing it out on your full color, photo-quality printer. With the increasing availability of digital imaging systems, including both video and still cameras, this process is becoming even easier and produces even higher quality images. Electronic imaging hasn't yet achieved the resolution of film, but that day is coming.

You can also use your computer as an electronic filing cabinet for photos taken the old-fashioned way (with your old 35mm camera). Scan the photos and store them on disks for easy retrieval.

picture clippings

The cheapest and easiest way to collect reference material is to snip pictures from magazines. There are several excellent wildlife photography publications on the market. Some of these are *Audubon Magazine*, *National Wildlife*, *International Wildlife*, *Natural History*, *National Geographic* and *Ranger Rick*. There are plenty of others. Visit your local library to become familiar with what is available, and subscribe to those you find useful.

However, make sure you only use these images as reference, because published images are protected by copyright.

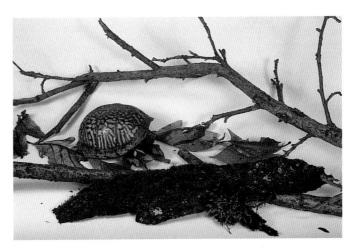

Props Collected on an Outing in the Woods

Computer Printouts From Video

finding a good composition

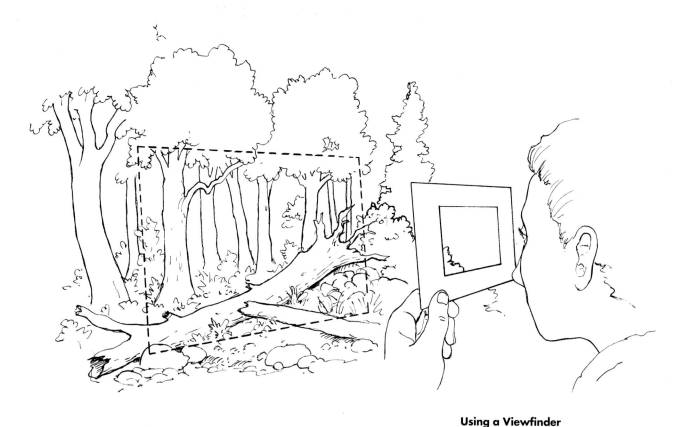

Using a Viewfinder

How do you know what works? The answer is different for every artist. However, there are certain rules of composition that every artist pays attention to.

the rule of thirds

A good starting point for composition is to divide the canvas into thirds horizontally and vertically. The places where those lines intersect provide good possibilities of locations for your subject.

balance

Avoid making your composition perfectly symmetrical, but it should be balanced.

use odd numbers

Animals or other major objects in your paintings should appear in groupings of odd numbers. A group of three or five deer looks less contrived than a group of two or four.

use a variety of sizes

In your painting, the elements of a group of objects should be different sizes. Nature's variety should come across in your painting.

keep the viewer in the painting area

Lines that run out of the corners of your painting will carry the viewer's attention away from the painting and, being so symmetrically placed, will look too contrived.

study other artists' artwork

If you have an art museum nearby, this is the best way to look at the work of other artists. Don't restrict your viewing to wildlife art.

Look especially at abstract and abstract expressionist works to see how the artist divides and balances the canvas, and how he develops an interesting play of line and form. Look at the palette or range of color the artist used. How do the colors affect the mood of the image? How do they balance with each other?

use a camera

The camera is a great place to practice composition. While you are gathering images to use as subject or reference material, you are using the viewfinder to frame images that you find in nature. Try picking out interesting forms, and compose a balanced and exciting picture in the camera. You can refine this, of course, when you plan out your final painting, but you begin the process as soon as you snap the picture. Sometimes you can find interesting compositions within pictures you've taken previously. Just crop out the stuff that doesn't work in the image.

use a viewfinder

Many artists use a small frame cut from matboard to compose images in nature while sketching. Just hold up the frame and look through it as you would use a camera's viewfinder, and you can "crop" an image from life.

developing your composition

You've studied your composition enough to know what direction to take with the design of your painting. Now it's time to develop your design through thumbnail sketches.

1 CAPTURE THE GESTURE
The first thing that the eye responds to is the arrangement of lines in your painting. Do a small gestural sketch to outline the major lines and forms of your painting.

2 COMPOSE IN ABSTRACT
Compose an abstract version of your painting with your next sketch, allowing the line and form to take center stage rather than any precise details. Arrange and play with the position of your shapes until they look balanced.

3 BLOCK IN SHAPE AND VALUE
Develop your basic shapes and values with a quick sketch to develop a pattern that will lead the viewer's eye to your subject.

Tell a Story

Every successful realist painting tells a story. The story could just be about the wonderful textures and colors, or it could be a drama about predator and prey. In any case, you have to arrange the elements of a painting in a way that lets the story unfold logically. You have to lead the viewer's eye through the complete story.

15

4 DEVELOP DETAILS

Keep going with your thumbnails, increasing the amount of detail each time until you have a realistic drawing that can be transferred to your painting surface.

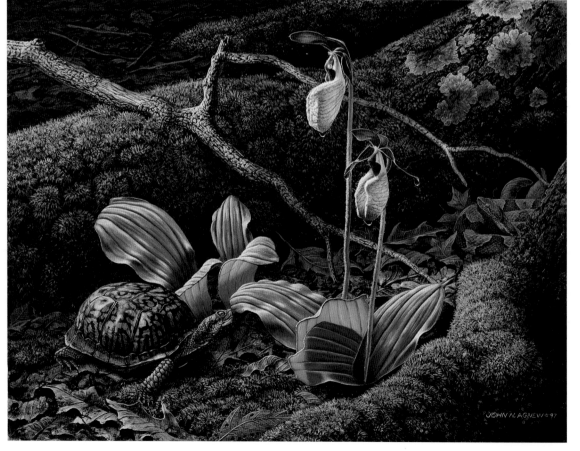

Spring Encounter
16" x 21"
(41cm x 53cm)
Acrylic on canvas

Planning your painting ahead of time will help keep it on track. Your collection of photo, video or magazine references, as well as your props, have helped develop your ideas. Your thumbnail sketches have helped develop your composition, and now your final detailed drawing is ready to be transferred to your painting surface.

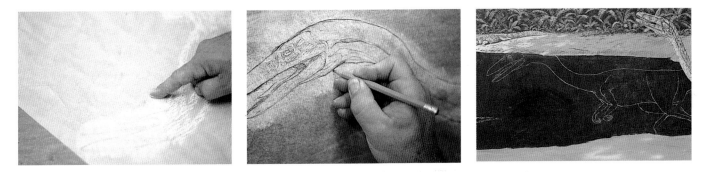

Use Chalk to Transfer Your Sketch to a Dark Surface

Rub white school chalk over the back of your drawing and then affix it to your painting surface, drawing side up. Retrace the lines of your drawing and remove. A chalk outline remains visible on the dark surface.

Use Graphite to Transfer Your Sketch to a Light Surface

Cover the back of your drawing with graphite (a no. 2 graphite stick works well). To make this coat of graphite more durable and free from smudging, coat the graphite with Bestene Rubber Cement Thinner, putting the thinner onto a rag and rubbing it gently across the graphite. Wear gloves and ventilate the room. Follow all precautions listed on this product.

Lay your drawing on your painting surface graphite-side down and trace over the lines of your drawing. A graphite outline will remain visible on the light painting surface.

supplies

acrylics

I was trained to paint with oils, but switched to acrylics when I began doing diorama and mural paintings for museums, because acrylics dry quickly and have a great flexibility. Also, acrylics do not generate unhealthy fumes, and they clean up with soap and water.

acrylics are versatile

Acrylics can be used like watercolors as thin washes, or like heavy oils in an impasto. You can make glazes with various types of acrylic medium. *Acrylic medium* is the acrylic emulsion without the pigment. It comes in various surface finishes—gloss, satin and flat. You can buy pure pigment and add it to acrylic emulsion to make your own paint.

mixing acrylics

It is important to mix acrylics thoroughly so you don't have little undissolved chunks of paint that make their presence known only after you've started to apply it. It is frustrating to be painting a nice clear blue sky, only to have a streak of Burnt Umber appear. I generally use acrylics mixed with water to a consistency like a thick gravy. This allows for smooth coats of paint and good coverage.

When mixing acrylics for an airbrush, it is important to strain your paints after mixing to prevent tiny chunks of undissolved paint from clogging the airbrush. Old nylon stockings work great for this.

Mix a little more paint than you think you'll need because it is difficult to match colors exactly. Extra paint mixtures will keep for a while stored in plastic containers with lids, but will start to develop mildew after a few weeks.

slow down acrylic drying time

Acrylics dry faster than oils—almost as fast as water. This can be an advantage, but there are effects that are only possible with slow-drying paint. For those, you can add an inhibitor to the acrylic paint to slow the drying.

To keep acrylics from drying too quickly on the palette, I keep a plant-misting bottle handy and spritz them occasionally.

When acrylics dry they are water resistant. This makes it possible to wash your painting with water if you need to, but it makes it difficult to remove dried acrylic from brushes or fabrics. Acetone will usually remove the dried acrylic in these situations. Also, hot water will soften dried acrylic on palettes, palette knives or airbrush parts.

palette

For a palette, I use an enameled metal butcher's tray. It will contain runny washes and is tough enough to allow vigorous scraping of dried paints.

surfaces

Your choice of painting surfaces depends on many factors, such as what sort of image you are creating, how it will be displayed and what its purpose is. I like to paint on smooth surfaces because it allows me to make very fine detail. Illustration board, Masonite, Claybord and Gessobord all have very smooth surfaces that allow for very fine detail, but may not be considered to be as permanent as canvas.

Canvas is the preferred surface traditionally, and is widely accepted by collectors as durable and permanent. When using canvas, I go for the smoothest and tightest weave I can get, such as portrait canvas.

When painting murals on walls, you're usually stuck with whatever you're presented. If you can have a say in how the wall is constructed, ask for drywall in situations where the mural is indoors and won't be exposed to water or physical abuse. For situations where the mural is outdoors or will be exposed to moisture, ask for cement plaster with a smooth steel-trowel finish.

For the demonstrations in this book I have used illustration board, but the techniques presented can also work on the surface of your choice.

brushes

Your choice of brushes is largely personal as well. The more you paint, the more you'll develop your own preferences, but don't ever stop experimenting with new possibilities. For general use I like the *bright*, a flat brush with sharp corners. It allows you to make wide strokes with the full brush and to make smaller details using the corners. You can even do both in the same stroke by twisting the brush as you move it. For tiny details I prefer sable rounds, which allow you to form a very sharp tip on the brush.

varnish *interesting*

When working with acrylics thinned with water, the colors sometimes lack depth and contrast. I often coat a painting with gloss medium to bring out the full range of color and contrast. This looks great with the lighting at the proper angle, but in poor lighting situations it can make the painting look too shiny, streaky or blotchy. One way to circumvent this problem would be to mix a little gloss medium with the paint instead of, or in addition to, water. This helps to suspend the pigment particles in a light-transmitting emulsion, rather than having them lying on top of each other in a "pile" that merely reflects and scatters the light. However, this technique presents its own problems, such as making the colors too transparent.

lights *IMPORTANT ↓*

How you light your work area can have a dramatic effect on how your paintings look. The color of light imparts color to the paints you use, so you must be careful of the color of your studio lights.

The ideal situation would be to paint under the same type of light as the place where the painting will be exhibited. Unfortunately, this is often impossible to predict. The best middle ground is to use daylight.

Because daylight is not always available or controllable, the next best thing is a daylight-simulating fluorescent light, or a mixture of incandescent light (a standard lightbulb is incandescent) and daylight fluorescence.

Most galleries use incandescent spotlights, and most people's homes are usually lit with incandescent lights. Be careful not to use lighting that is too bright. Your painting may end up looking too dark in other lighting situations.

mold rubber as frisket

I use latex mold rubber as *frisket* to mask off the areas I don't want paint to cover, and to give certain shapes a sharp edge. It goes on as a milky color, which makes it easy to see what you've covered, and then dries almost clear, allowing you to see the work beneath the frisket. After painting, I can peel it off and it won't stick to my acrylic paint.

It's easier to use on canvas than the sticky-backed frisket paper because it does not require using a sharp razor on your canvas, and you can paint intricate shapes more easily than cutting them. It can be a little tricky to use at times and may ruin a few brushes, but I find it to be a versatile material.

Watercolorists sometimes use rubber cement as frisket, but the solvents in rubber cement may attack acrylic paint. Latex mold rubber works fine on any nonporous surface, such as primed canvas or illustration board.

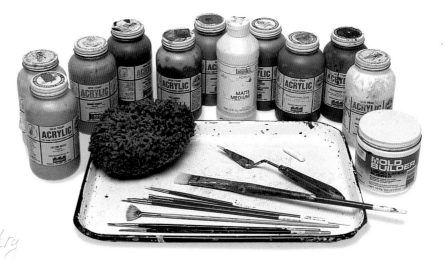

My General Tools

19

using an airbrush

The airbrush is a wonderful tool, making it possible to paint smooth, even layers of color in a short amount of time. It takes a little practice to become proficient, but once you've learned, you'll find the airbrush an essential tool.

The airbrush has been looked down upon by some artists as "cheating," but I don't believe it is at all. The airbrush is just a tool like a traditional brush. It requires skill and vision to be used successfully. Once, while painting murals in the zoo and holding my airbrush while contemplating my next move, a visitor looked at my airbrush and sneered, "So that's how you do it!"

Try not to *overdo* it. Paintings that look airbrushed are not successful, in my opinion. Reserve the airbrush for situations that call for subtle, smooth gradations in value or color, such as the gradual change in a sky from the deep blue overhead to the hazy horizon below.

troubleshooting

Part of becoming skilled with the airbrush includes being able to solve problems quickly. It can be extremely frustrating to use the airbrush if you can't make it work correctly. Be able to *field strip*, or disassemble and re-assemble, it easily.

Here are some typical problems and their solutions.

The flow of paint is erratic and won't work at low air pressure levels.

The tip of the needle gets clogged with paint. Remove the airbrush tip, exposing the needle, and carefully wipe it with your fingers. There may also be a particle blocking the flow inside the airbrush between the paint cup and the tip. Unscrew the tip about three turns and blow some air through it, causing the paint to bubble up in the cup. This should blow back any trapped particles. If the problem continues, the tip itself may be clogged, and needs to be soaked in water or solvent and then carefully reamed out.

Paint comes out in a splatter pattern.

You may not have sufficient air pressure, or the paint may not be thinned enough.

The airbrush is splattering water onto my work.

The compressor will cause condensation to build up in the airhose, especially in humid conditions. A moisture trap on the compressor or airline will solve this. Otherwise, you need to run the compressor with the airbrush removed from the hose for a while, allowing the water to blow out.

The paint splatters in a "splash" pattern when I use it close to my work.

You may have too much air pressure from the compressor, or you are allowing too much airflow at the airbrush. Don't pull the trigger back so much, or adjust the pressure regulator on the compressor.

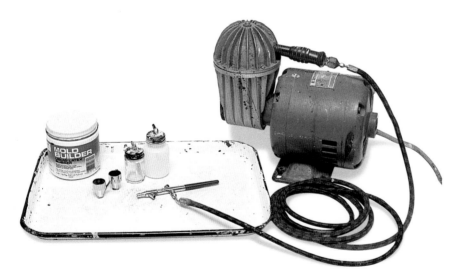

The Airbrush
This is the airbrush setup that I normally use in my studio. A Badger model 150, dual-action airbrush with a Paasche Type D ¼ horsepower compressor. A quieter alternative to the compressor would be a tank of compressed air, but these tanks require periodic trips to get them refilled.

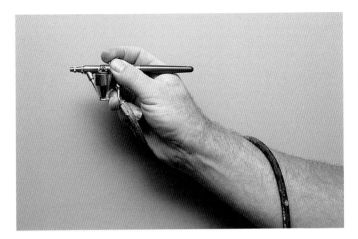

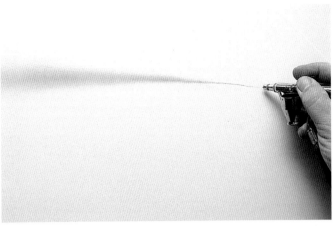

Proper Way to Hold the Airbrush

Grip the airbrush as you would a pencil or small paintbrush. Looping the airhose around your wrist eliminates the drag that the weight of the hose can cause. This gives you better control of the airbrush. When working close to the painting surface, keep your little finger extended and in contact with the surface. This helps to steady your hand and gives you better control of the airbrush-to-surface distance.

Varying the Spray Pattern

The airbrush is capable of a wide range of spray widths, which are controlled by the distance you hold the airbrush from your work. A very fine line is possible when holding the airbrush very close, but you must restrict the flow of air and paint to very low levels. Trying to spray too much paint with too much airflow can cause runs and drips to occur. When you are covering wide areas, hold the airbrush further away and increase the air and paint flow.

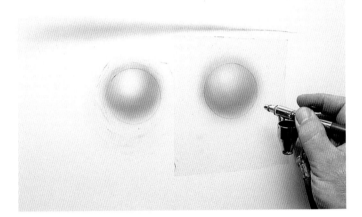

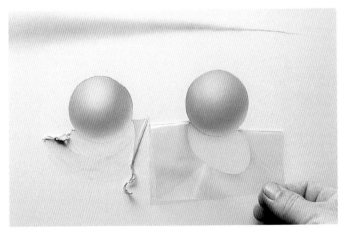

Two Ways to Mask Areas for Spraying

On the left is latex mold rubber that has been brushed around a circle form. On the right is frisket "paper," actually a thin, flexible plastic sheet with an adhesive back that is laid over the drawing and then cut to shape with a knife.

Latex Rubber Vs. Frisket Paper

Latex Rubber

pros: Easier to mask around intricate shapes; won't stick to paint; doesn't get blown off the surface by airflow from airbrush.

cons: Tends to ruin brushes used to spread it; can sometimes leave a faint stain when the ammonia in the rubber reacts with painted surfaces.

Frisket Paper

pros: Easier to create smooth curved or straight lines; more transparent than rubber; you can reuse pieces already cut and peeled away from work.

cons: Difficult to cut around complex shapes; hard to use on surfaces such as canvas, where your knife may cut through; sometimes sticks to and pulls off underlying paint; airflow from airbrush can dislodge it from your work.

chapter 2

creating that "secret feeling"

What is it that gives a painting a feeling that you are peeking in on a secret place in nature? What can you do to make a scene look mysterious and moody? The secret lies in the combination of the point of view and the lighting you use, plus any incidental details you add.

The primary tool you can use to create your desired mood is the composition. A point of view that is different from the way you are used to seeing can add to the sense of secrecy or mystery. The mood of a painting can also be manipulated through the use of light and atmosphere. Put some secrets into the painting. Some partially hidden animals (other than the subject), placed the way you might discover them in nature, can lend a sense of discovery to the scene.

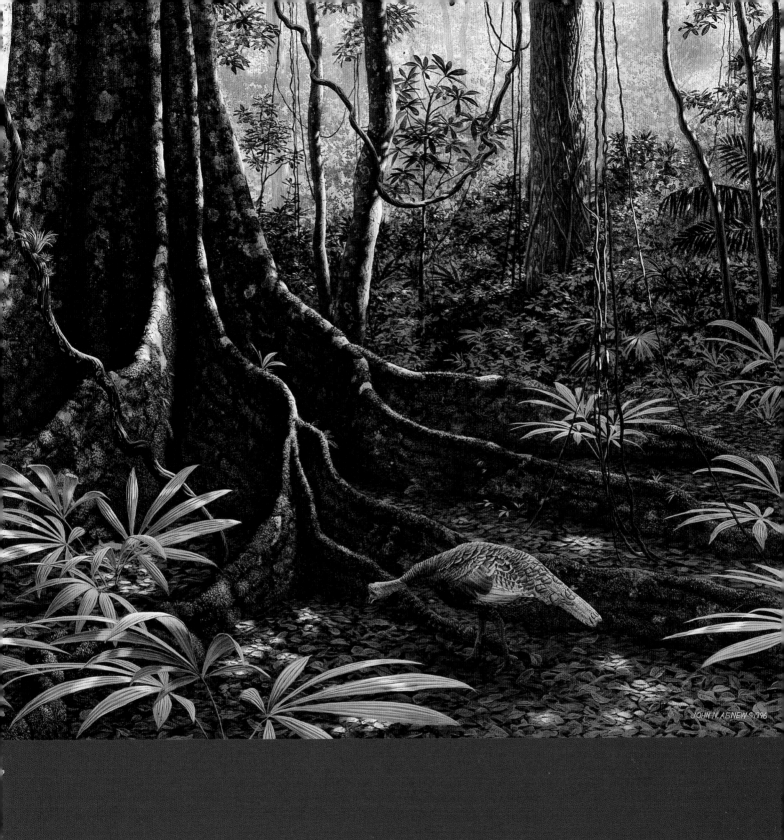

composition

Paintings can give the viewer a sense of discovery through the use of camouflaged animals, a close-up or tight viewpoint or an unusual point of view.

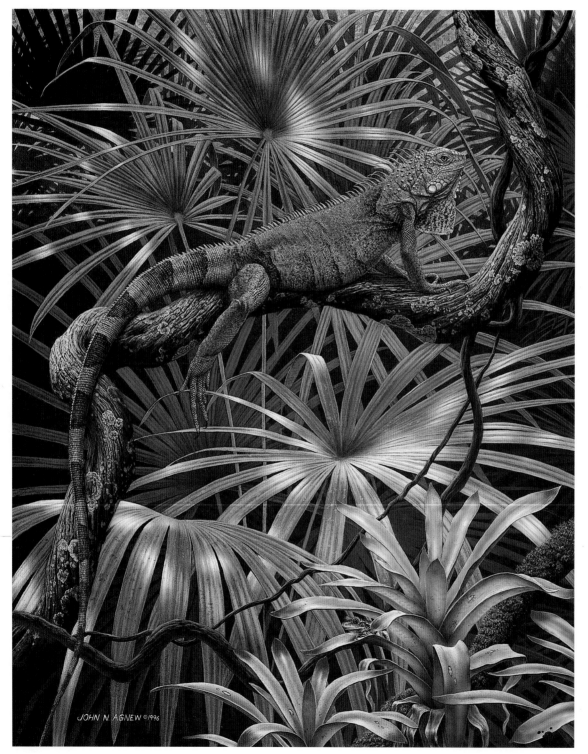

Find the tree frog hidden in the leaves.

Morning Warmup
32" x 24"
(99cm x 61cm)
Acrylic on canvas

lighting

Lighting can determine the mood of a painting. A dark, somber painting can feel mysterious or gloomy. Spotlighting an animal in the forest with dappled light can give the feeling of a secret place.

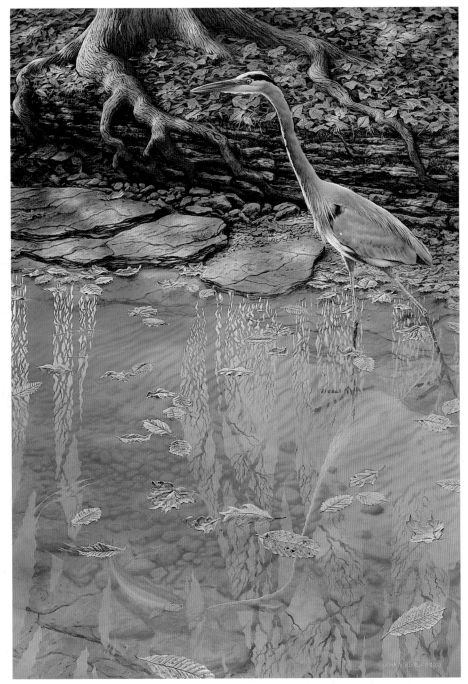

The Forest Pool conjures feelings of an obscure pool in a small forest stream. Inhabited only by trout and a visiting Great Blue heron, it has the feeling of a secret place.

This feeling is enhanced by the dappled lighting of a deep forest. This tells us that the scene lies under the cover of trees, hidden from view. Also, the murky depths of the pool lend an air of mystery to the water. Parts of the pool bottom are obscured by the reflection of sky and trees, a hide-and-seek effect that implies that there is more to be seen.

The Forest Pool
33" x 23" (84cm x 58cm)
Acrylic on canvas

Details like water reflections, dewdrops or insect damage on leaves add a sense of intimacy, especially if they are related to the subject.

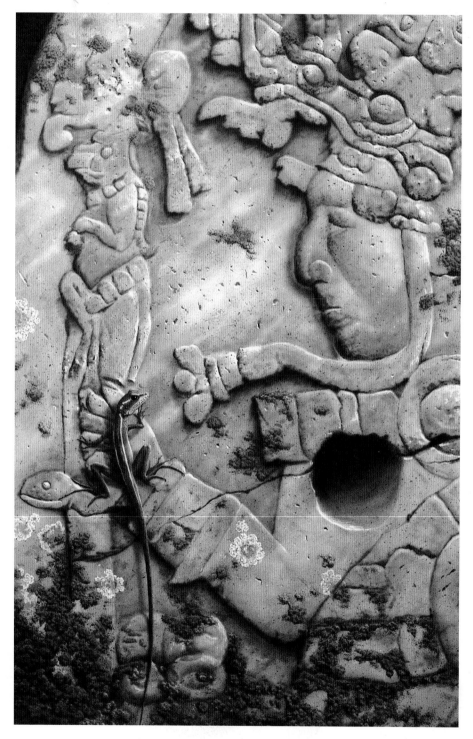

Ruins of ancient civilizations have always held an air of mystery and secrecy, especially when they are buried deep in the jungle. Equally mysterious are the small creatures that have made the ruins their home.

While this painting is essentially a portrait of a Basilisk lizard, the background and all of its elements tell a story of their own. The details such as the lichens growing on the stone, the clumps of moss and even the Mayan sculpture itself become incidental touches that put the animal into an interesting context. The reptilian imagery carved in the stone relates back to the subject animal and reminds us of the relationship of the Mayans to their environment. The tiny details such as the weathered texture of the stone and the moss and lichens add life to the small world of the basilisk. All of these elements together build a stage for the lizard and our imagination.

Basilisk on Mayan Stela
30" x 20" (76cm x 51cm)
Acrylic on illustration board

Atmosphere is related to lighting, but includes the use of fog, mist, humidity and other weather conditions to create a mood or a sense of mystery.

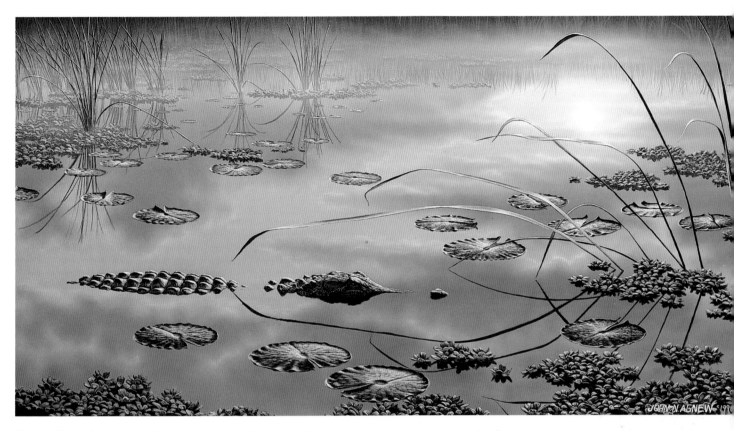

The use of fog in this painting helps to create a sense of mystery and sets a peaceful mood. The mystery relates to the partially submerged alligator; the peaceful setting contrasts with the alligator's potential for sudden violence.

Sunrise
17" x 32" (43cm x 81cm)
Acrylic on canvas

contrast

Contrast can be adjusted for different effects. A prime use of contrast is to create depth. This works especially well when trying to paint atmospheric perspective: The foreground would be in sharper contrast; distant objects would have the least contrast.

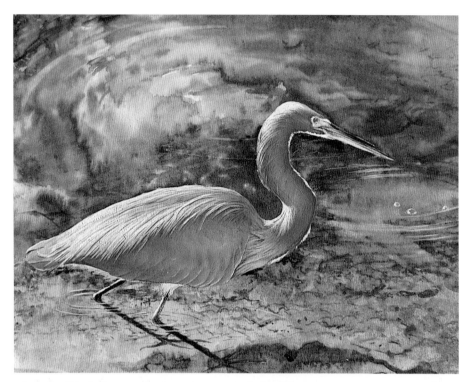

High Contrast
Bold contrast can give an object more presence and enhance a dramatic feeling.

Tricolored Heron
8" x 10" (20cm x 25cm)
Watercolor and gouache on paper

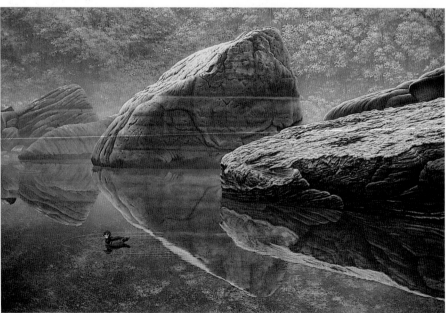

Low Contrast
Low contrast can give your painting a dreamy, peaceful mood.

Morning on the Rockcastle
32" x 48"
(81cm x 122cm)
Acrylic on canvas

Color can determine the type of light and atmosphere that you create. The time of day, the light source and the mood of the scene can all be determined by simply altering the color of the light. Look at the difference that color can make in the very same scene.

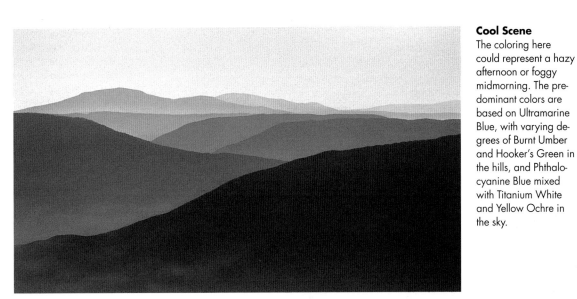

Cool Scene
The coloring here could represent a hazy afternoon or foggy midmorning. The predominant colors are based on Ultramarine Blue, with varying degrees of Burnt Umber and Hooker's Green in the hills, and Phthalocyanine Blue mixed with Titanium White and Yellow Ochre in the sky.

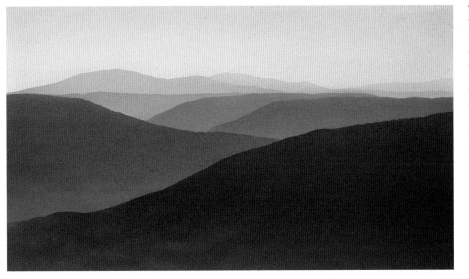

Warm Scene
This is the very same painting as the one above, but with a light covering of Hansa Orange applied over it with an airbrush. This warmer scene could represent a hazy sunset or foggy sunrise.

creating haze, fog and humidity with an airbrush

The scene here depicts a landscape with distant hills receding into the haze. Not exactly a "secret" place, but it should give you a clear idea of how to take full advantage of the airbrush. Haze can be used to create moods, to add mystery or to create atmospheric perspective. The airbrush is a very effective tool for this, especially in situations where you need a very smooth gradation of color against a solid background such as a sky or water.

1 PAINT THE SKY

Always start with the most distant subjects. In this instance, the furthest subject is the sky; airbrush it in with a soft blue made from Titanium White, Phthalocyanine Blue and a touch of Yellow Ochre. Then airbrush in a layer of haze near the horizon, using a mixture of Titanium White and Yellow Ochre. Use a steady, horizontal stroke, applying a very small amount of paint with the airbrush in each stroke. It is always best to build up the paint slowly. By going slow, you can control the coverage better and you get an even, splotch-free haze. You can always add a little more, but taking it off is a problem.

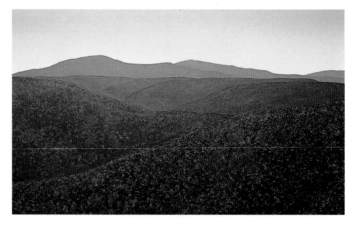

2 PAINT THE HILLS

The hills have a fairly smooth edge, so you can paint several layers of them at once. Adjust the color of the hills from blues (Ultramarine Blue plus a little Titanium White and Burnt Umber) in the distance to warmer colors (Hooker's Green plus Ultramarine Blue and Burnt Umber) in the foreground. Before putting in the additional haze of step 3, be sure to finish any detail work, such as trees on the hillsides, with your no. 4 or no. 6 brush.

MATERIALS LIST

paints
- Titanium White
- Pthalocyanine Blue
- Ultramarine Blue
- Yellow Ochre
- Hooker's Green
- Burnt Umber

brushes
- bright (synthetic): no. 4
- round (synthetic): no. 6

other
- airbrush
- latex mold rubber or other frisket

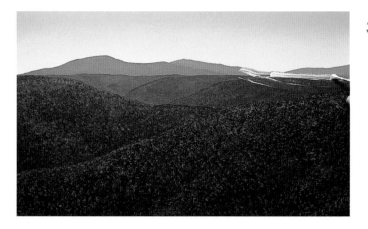

3 MASK THE EDGES OF THE HILLS

After you've painted a layer or two of hills into your scene, you're ready to add haze. Paint mold rubber carefully over the edges you want to mask. Make sure you cover an area wide enough to prevent overspray from going into places where you don't want it. You don't need to cover the whole painting, just a few inches beyond the work area, enough to give you some working room.

Layer of haze added to background hills. Peel off mask.

4 AIRBRUSH IN THE HAZE

Do this in order, from the most distant hills to the closest. The haze color here is a mixture of Titanium White and Yellow Ochre. Other color combinations you can use are Titanium White with Phthalocyanine Green plus Naphthol Red, or Phthalocyanine Green and Dioxazine Purple. These combinations give you a blue to purplish haze color, depending on which hue you favor. Mix the colors thoroughly, strain them through an old nylon stocking, and then airbrush on, let dry and peel off mask.

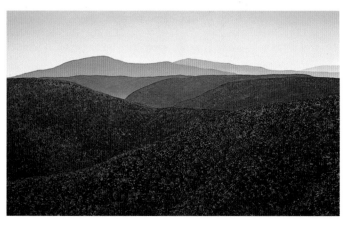

Layer of haze added to midground hills.

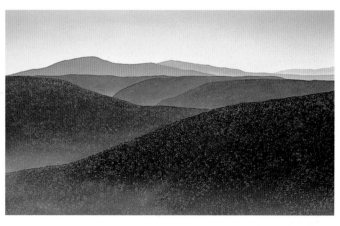

Layer of haze added to foreground hills.

creating haze, fog and humidity with glazes

Creating fog and haze with acrylic glazes is a reasonable substitute for the airbrush. However, this technique works better when it is applied over a background with varying contrasts, such as leaves or rocks. It is difficult to achieve a streakfree fog with glazes, but with a complicated background, it isn't very noticeable.

Sometimes it's nice to be able to skip the setup and cleanup involved with the airbrush, and painting the glaze into small areas is often easier than using the airbrush. With a glaze, you have more control of where the paint goes, and the need for masking is reduced.

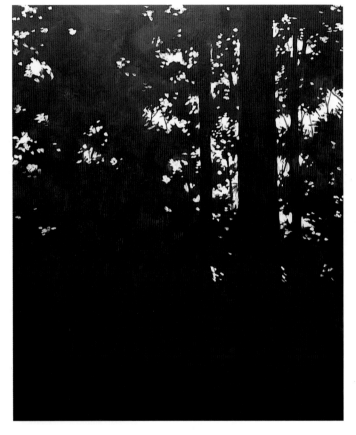

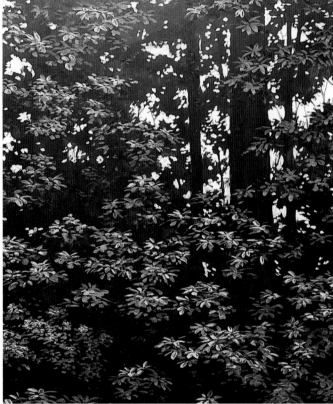

1 APPLY BASE COLOR

Paint shadowy dark colors as a base for the leaves that will come, and for the silhouettes of distant trees, using Ultramarine Blue with a small amount of Hooker's Green and Burnt Umber. The mix should be mostly blue, but you may want to add a touch of Titanium White to keep it from looking too dark. Because there is not much sky showing through the leaves, it may be easier to paint the entire surface with the base color and then add the bits of sky on top of it later. Paint in the dark, shadowed leaves with a no. 4 or no. 6 brush. Start with a dark green mix of Ultramarine Blue and Hooker's Green. Use a loose stroke: You don't need to be detailed yet.

2 BUILD UP BRIGHTER LEAVES AND HIGHLIGHTS

Mix the Hooker's Green with a little Titanium White and a touch of Ultramarine Blue. Keep this mixture fairly close to the value of the first layer of leaves. Build up another layer or two of brighter leaves on top of the first layer, and then add bright highlights.

MATERIALS LIST

paints
- Ultramarine Blue
- Burnt Umber
- Hooker's Green
- Titanium White

brushes
- brights (synthetic): no. 4, no. 6, no. 10

other
- acrylic matte medium or glazing medium

3 ADD THE FOG GLAZE
After you've finished all of the details you want in the scene, you can start the glazing process. Mix acrylic matte medium with Ultramarine Blue and a very tiny amount of Titanium White. The trick to doing good glazes for fog or mist is too keep the pigment very thin in the glazing medium. Mix the glaze with water until it is pretty runny but not quite watery. Apply it to the painting with a no. 10 brush, building it up slowly, layer by layer, letting each layer dry before adding the next. If you see streaks in the glaze, you have too much pigment in it and/or you haven't added enough water. Add extra glaze around the spots of sky in the upper leaves to enhance the fogginess.

4 ADD A CONTRASTING FOREGROUND
After finishing the fog glazing, paint in some trees or foliage in the foreground, keeping the colors dark or contrasty. This will help make your background look even more foggy and will add some drama to the scene.

form and texture

The airbrush is a quick way to build form with light and shadow. Often when painting animals such as snakes, I use the airbrush to build the animal's form, using shadow to define the animal's volume.

1 PAINT IN THE GROUND COLOR

Draw a snake and transfer it to your painting surface. Only do the outline at first, because you'll cover most of the details inside the snake's form. After the drawing is done, mask the edges with latex rubber or other frisket.

Airbrush in the ground color with a mix of Hansa Orange and Burnt Umber. Add the eye and any other drawn details back on the snake as needed.

2 PAINT IN THE COLOR PATTERN

Paint in the color pattern of the snake, in this case using the airbrush and a mix of Burnt Umber and Ultramarine Blue.

3 ADD SHADING AND BUILD FORM

Now it is time to airbrush in the shading to build the snake's form. It may be necessary to mask some of the interior lines in order to preserve their sharp edges.

Use the Burnt Umber-Ultramarine Blue mix to airbrush in the shadows that will build the volume of the snake's body. Pay attention to the light source in the painting, and be consistent with how it defines the form.

Add scales and highlights with your no. 4 round sable (see Snake Scales, page 77) and remove mask.

MATERIALS LIST

paints
- Hansa Orange
- Burnt Umber
- Ultramarine Blue
- Titanium White

brushes
- round sable (natural): no. 4

other
- airbrush
- latex mold rubber or other frisket

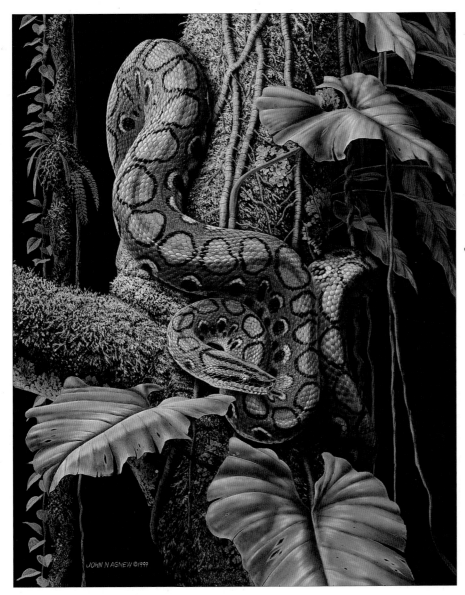

In this painting, the rainbow boa's ground color was laid in first, using Cadmium Orange mixed with a little Burnt Umber and Ultramarine Blue. The shadow areas are sprayed in with the Burnt Umber-Ultramarine Blue mixture. I used a frisket to mask the edges of the snake's body to maintain the sharp edge.

How you treat the light on an animal's body says a lot about the mood you are trying to portray. The soft light on the rainbow boa's body suggests a sensuous, graceful animal. Harsh sunlight with bright highlights and contrasty shadows bringing out the hard edges of texture on the snake's scales might suggest a more "hard-edged" personality for the snake.

Brazilian Rainbow
20" x 15" (51cm x 38cm)
Acrylic on illustration board

afternoon light

The light of late afternoon is fascinating with warm colors and the drama of long shadows and reflected light. Use a warm underpainting to keep the colors of the painting all in the same range.

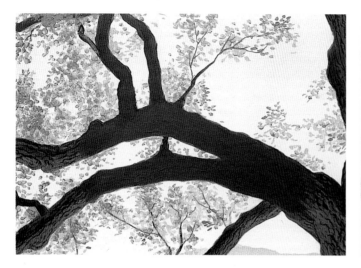

1 PAINT BASECOAT
Apply the base color of the tree with Burnt Umber, a touch of Ultramarine Blue and a touch of Titanium White using your no. 5 bright.

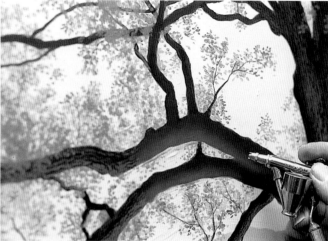

2 PAINT REFLECTED LIGHT
Because the bright light from the ground will reflect onto the lower sides of the branches, airbrush a mixture of mostly Raw Sienna with a little Titanium White onto the sides of the branches facing the ground.

3 PAINT BARK TEXTURE
Use straight Ivory Black with a fine brush such as your no. 3 round to add texture to the tree, painting the deep grooves of the bumpy bark.

MATERIALS LIST

paints
- Yellow Ochre
- Raw Sienna
- Burnt Umber
- Ultramarine Blue
- Titanium White
- Ivory Black

brushes
- bright (synthetic): no. 5
- round (synthetic): no. 3

other
- airbrush
- natural sponge

4 ADD HIGHLIGHTS

Highlight the bark texture with pure Raw Sienna. If you need to brighten the highlights here, add a little Yellow Ochre to the mix.

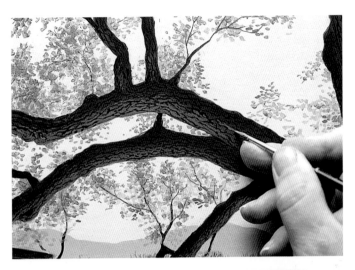

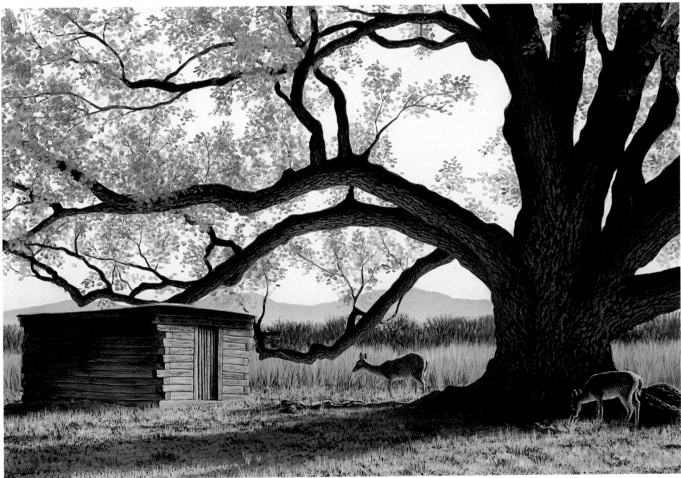

San Pedro Cabin
15" x 20" (38cm x 51cm)
Acrylic on illustration board

midday light

The brilliant light of midday can create some dramatic lighting situations in a painting, especially when combined with intense shadows. The deeper the shadow, the more brilliant the light will seem to be. Midday light basically comes from directly overhead and creates very distinct and contrasty shadows.

1 SKETCH AND UNDERPAINT

Draw in the shapes of the rocks and the tree with a pencil, and then trace over the pencil lines with dilute Ivory Black and a no. 4 sable. Coat the entire scene with a wash of Yellow Ochre thinned to a watery consistency; use a natural sponge to apply it. Don't worry about getting a smooth coat: It's even better if it's splotchy.

2 APPLY A TEXTURE COAT

Using a mixture of Burnt Umber and Ultramarine Blue, apply a "stone" texture coat with the natural sponge (see chapter 3, page 56). Keep this initial coat light by using watery paint.

3 SHADE AND CREATE FORMS

Use the airbrush and the Burnt Umber-Ultramarine mix to shade the forms of the tree and rocks. Make the shading on the tree most intense near the upper, sunlit edge. Fade it toward the bottom side so that it becomes lighter, indicating reflected light from the rocks below. This helps with the illusion of brilliant light. In the areas of water, overpaint the rocks with a wash of Raw Sienna as the color of the water.

MATERIALS LIST

paints
- Yellow Ochre
- Raw Sienna
- Burnt Umber
- Ultramarine Blue
- Ivory Black
- Titanium White

brushes
- brights (synthetic): no. 6
- round sable (natural): no. 4

other
- airbrush
- natural sponge

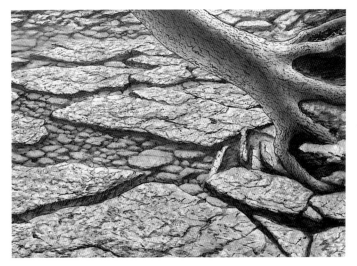

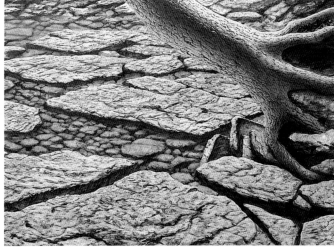

4 ADD TEXTURE

Using the no. 4 round sable brush and the no. 6 bright, begin adding texture and continue building the forms of the tree and rocks. Make sure to indicate some perspective in the surfaces of the rocks by suggesting a few lines in the rock texture. Also, work in the harsh shadows created by the intense midday sun. Note the fossil shells in the foreground rocks. Details like these add interest.

5 ADD HIGHLIGHTS

Mix some Yellow Ochre, Raw Sienna and Titanium White in a bright mix, and apply highlights with the no. 6 bright and the no. 4 round sable brushes. Highlight the tree trunk's upper side with very bright highlights, and do the underside with a dimmer mix of Raw Sienna and Titanium White.

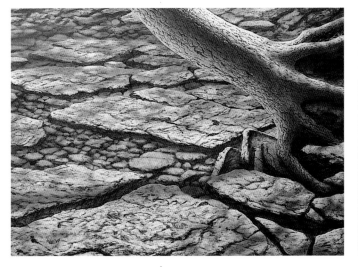

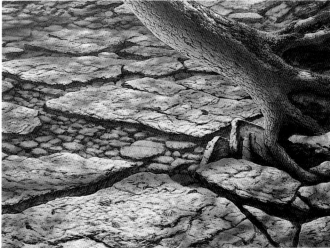

6 ADD SHADOWS

Because the intensity of light in a painting is actually controlled by the depth of the shadow, make the leaf shadows on the rocks fairly dark. Mix Ivory Black and Ultramarine Blue and thin it for the airbrush. Add a shadow for the tree trunk and a pattern of leaf shadows from the forest canopy. You can deepen the shading on the tree and rocks where necessary while you have the airbrush loaded with this deep-shadow mix.

7 MOSS

For the basic moss technique, refer to chapter 3, page 52. Here you use a mix of Hooker's Green and Cadmium Yellow over an outline shape made with Ivory Black.

dappled light

Creating the dappled light of the deep forest is a great way to catch atmosphere and the feeling of a "secret" place. It's not a difficult technique, but it does require the careful observation of the play of color, shadow and highlight.

Sit in the woods on a summer day and take notes and sketches of the light and shadow. The spots of sun have a warm, yellowish appearance; the shadows are a deep green-blue. Observe the shapes of the sun patches as they wrap around the forms of trees or leaves.

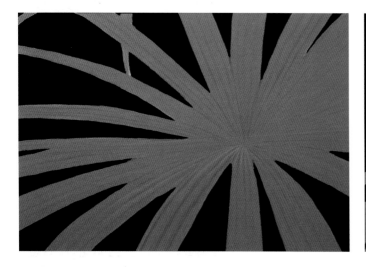

1 APPLY BASE COLOR AND TEXTURE
Because most of the palm is in shadow, the base color should be cool and dark. Mix Chromium Oxide Green with Ultramarine Blue and apply it as a smooth, even coat over the palm. It may require several coats to achieve a dark enough color.

When dry, start adding the "corrugated" texture to the palm with a dark mix of Hooker's Green and Ultramarine Blue.

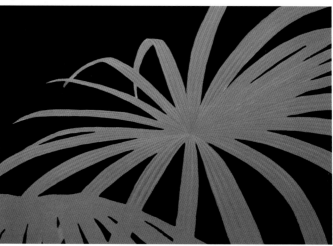

2 HIGHLIGHT PALM TEXTURE
Mix a lighter shade of your base color by adding some Titanium White and a little more Ultramarine Blue. Use this lighter color to highlight the palm texture, emphasizing the "corrugation" of the palm.

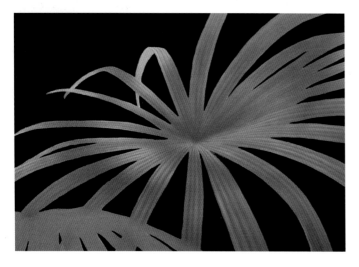

3 ADD SHADOW
Airbrush in the shadows in the leaf form and the shadows cast by other leaves with a dark mixture of Hooker's Green and Ultramarine Blue.

MATERIALS LIST

paints
- Ultramarine Blue
- Chromium Oxide Green
- Hooker's Green
- Cadmium Yellow
- Titanium White

brushes
- brights (synthetic): no. 4, no. 10
- round (synthetic): no. 6

other
- airbrush

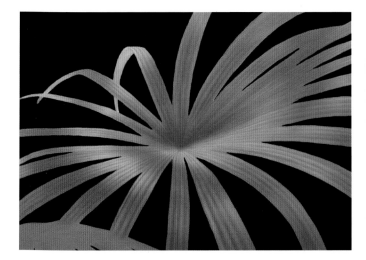

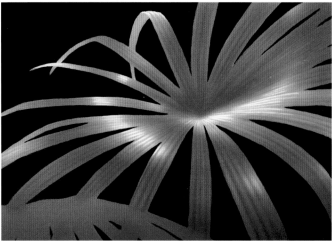

4 PAINT ON THE SUNLIGHT
Define and cover sunlit areas by airbrushing a light coating of Cadmium Yellow for a dappled effect. Allow the green to show through beneath the color.

5 MAKE THE SUNLIGHT WARMER
Then airbrush in a bright light color mix of Cadmium Yellow and Titanium White, being careful not to cover all of the softer yellow. This will give your sun spots a warmer feel.

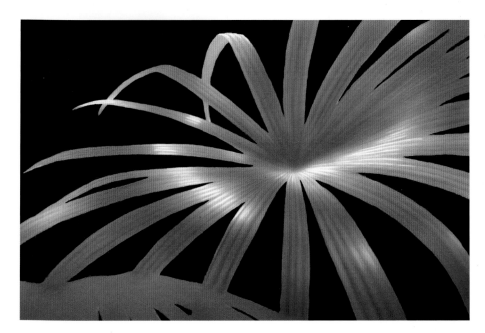

6 FINISH UP WITH HIGHLIGHTS
Come back with some of the yellow-white mixture of step 3 and use a drybrush technique to add the brightest highlights to the ridges and edges of each leaf. Use very little pigment in your brush, and try smoothing the paint out with your finger after every few strokes. This keeps the highlight soft and will hide any messier strokes.

hard vs. soft edges

Controlling the softness or hardness of edges in your paintings can be a way to emphasize your subject or to create a sense of depth. The airbrush is a great tool for this because it automatically makes a soft edge, but the effect can be achieved by hand as well. The drawback with this technique is that it can make a painting look a little too much like a photograph. Because the zone of focus, or "depth of field," in a photograph is limited, we often see the subject in sharp focus with a blurred or soft background. We are so used to seeing this in photos that when we see the same thing in paintings, we often think "photograph." A painting that overuses this effect can look like a copy of a photograph.

1 APPLY BACKGROUND COLOR
Coat the surface of the painting with a solid color, in this case Chromium Oxide Green mixed with Ultramarine Blue and Titanium White. You are attempting to simulate the color of the leaf canopy against an overcast sky. The forest is foggy, so don't make the mixture too dark.

Sketch out your tree and branch placement and then add the sky using an airbrush and negative painting, creating the sky gaps between the leaves. The airbrush will give you a consistently soft edge.

2 ADD A SECOND LAYER OF LEAVES
Add another layer of leaves in slightly sharper focus. The color should be a bit warmer and darker. Add a touch of Cadmium Yellow and Burnt Umber to the leaf mixture used in step 1.

MATERIALS LIST

paints
- Ultramarine Blue
- Hooker's Green
- Cadmium Yellow
- Chromium Oxide Green
- Burnt Umber
- Ivory Black
- Titanium White

brushes
- bright (synthetic): no. 6
- round (synthetic): no. 4

other
- airbrush

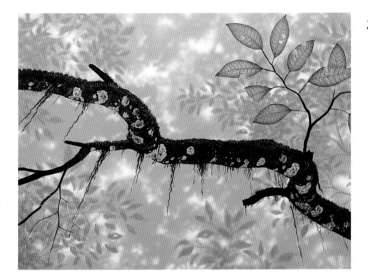

3 PAINT THE FOREGROUND AND THE SUBJECT

Using brushes, add in the foreground and the subject, keeping it in sharp focus. This should make it stand out from the background and give the scene a real sense of depth. Use a mixture of Hooker's Green and Cadmium Yellow for the leaves, and Ivory Black mixed with Hooker's Green for the branches.

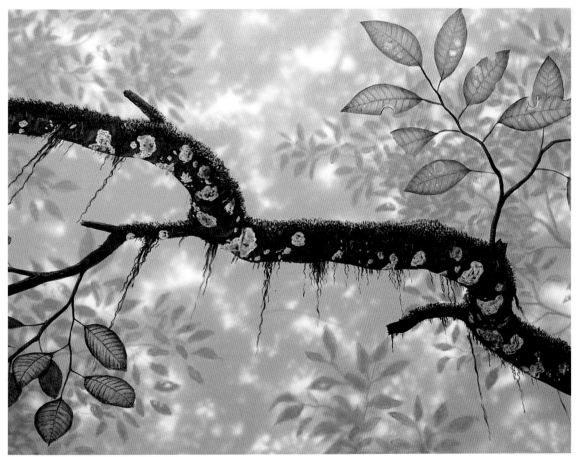

Guardian of the Gods
24" x 32" (61cm x 81cm)
Acrylic on canvas

chapter 3

painting the textures of the environment

One of the most important aspects of realist paintings is the creation of objects with realistic textures. This gives our artificial world credibility and gives our eye a world to explore. Sometimes you can create realistic textures with illusions that are easy to perform. Other textures require painstaking draftsmanship. This chapter will take you through a variety of demonstrations designed to help you create the textures that will help bring your environment into focus, breathing life into your paintings.

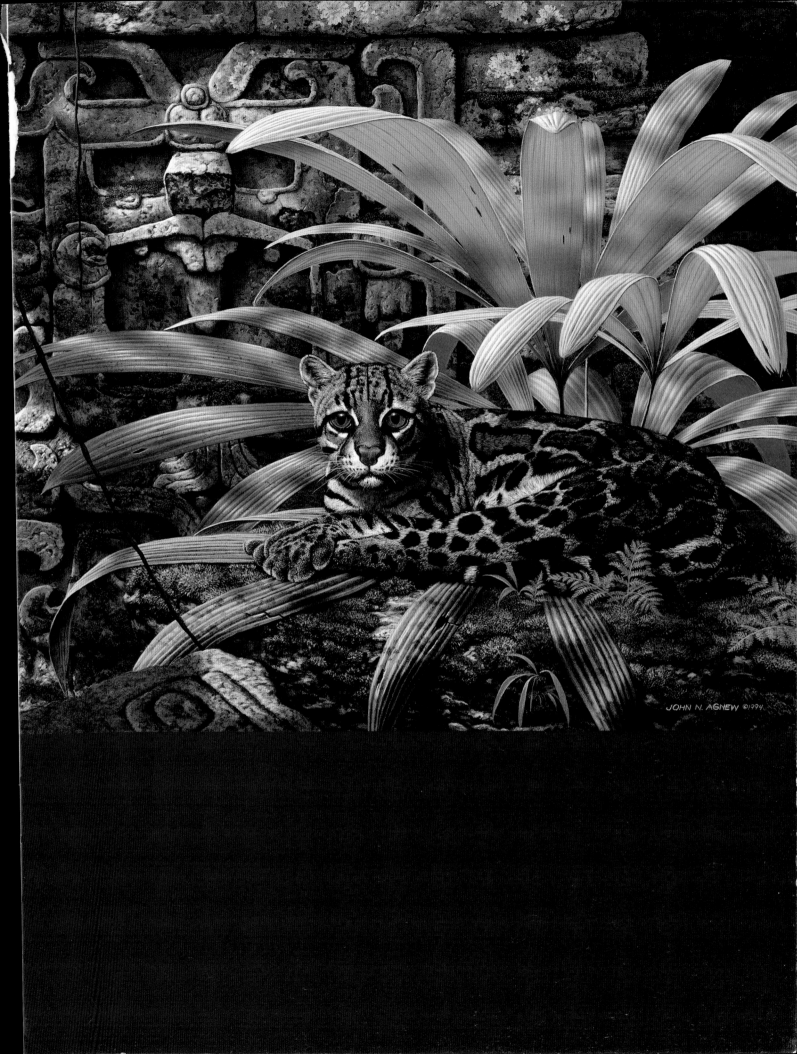

JOHN N. AGNEW ©1994

dried leaves

Creating the deeply textured debris of a forest floor is a great job to start with a natural sponge.

1 LAY IN A TEXTURE COAT

Mix Ultramarine Blue and Burnt Umber, going heavy on the umber, to achieve a dark, cool brown color. Thin it into a wash and load the sponge heavily. Smear it over the canvas, going back to dab in the texture before it dries. You don't need to reload the sponge: Just use what you've smeared on. Cover your leaf area with this texture. If it appears too light, lightly dab on some more of the dark brown mixture. You can do this texture over a warm or cool underpainting to achieve the effect of sunlight or shadow.

2 SKETCH IN LEAF SHAPES

You'll need good reference material, but you don't need to get too accurate right away. Draw in the leaf shapes with your no. 4 bright and the dark brown mix used in step 1. Try some fairly random strokes, creating debris and suggestions of leaves. Sketch in the texture of broken bits of leaves using your no. 4 bright, making little twisting motions with a light stroke. Sketch out a few complete leaves.

3 ADD SHADOWS AND HIGHLIGHTS

Go back in with Ivory Black or another dark mix (such as Phthalocyanine Green and Acra Violet) and begin to create shadows under the edges of leaves and debris. Use your finger to soften the bottom edges of some strokes to make a shadow effect.

Add highlights with a mixture of Titanium White, Burnt Umber and Yellow Oxide on the leaf edges, along veins and in the debris. On the leaf edges facing you, create the highest contrasts between light and shadow. Use your no. 4 round sable to edge the leaf edges with your brightest highlights (Titanium White with a touch of Burnt Umber and Yellow Oxide), and underscore those edges with your deepest darks (Ivory Black or a mix of Phthalocyanine Green and Acra Violet). This makes those edges seem to project forward.

MATERIALS LIST

paints
- Ultramarine Blue
- Burnt Umber
- Yellow Oxide
- Phthalocyanine Green
- Acra Violet
- Titanium White
- Ivory Black

brushes
- bright (synthetic): no. 4
- round sable (natural): no. 4

other
- natural sponge

green leaves

Leaves are so varied that there is no single method or color for painting them. Study the leaves you want to do to determine how to recreate them. For large leaves or close-ups, the airbrush is great for shading and highlighting the leaf, with added work by drybrush technique to give it texture and other details. I prefer using a flat brush for small or distant leaves.

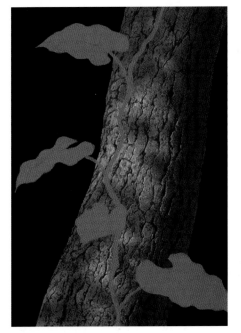

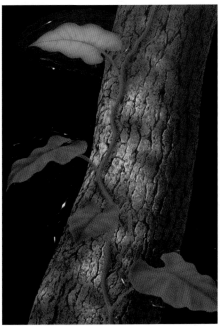

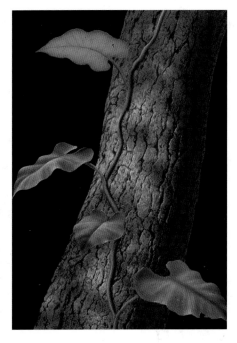

1 LAY IN BASE COLOR

Use a no. 6 bright to lay in your base color of Chromium Oxide Green plus Cadmium Yellow or Ultramarine Blue to warm it or cool it. How you modify the green depends on the lighting situation (sun or shadow) and the color of the leaves.

2 ADD DARKS

Some variation of Hooker's Green mixed with Burnt Umber and/or Ultramarine Blue works well for leaves as a shadow color. Use an airbrush to shade leaves that are shiny or smooth in appearance. Use a no. 4 round brush to add veins or other textural details. When portraying leaves that are backlit, try airbrushing on some pure Cadmium Yellow over the base color. You can also just brush on a mix of Cadmium Yellow with a touch of Hooker's Green or Phthalocyanine Green. Here you can see the latex mold rubber around the leaves as masking for the airbrush.

3 ADD HIGHLIGHTS

Mix Titanium White into the base color and add a little Cadmium Yellow as a highlight color. If your highlights are in shadow, use the white, green and a little Ultramarine Blue. Use the airbrush to highlight smooth leaves; use a detail brush for fine highlight or texture. Use sharp contrast on forward edges of the leaves. Add a few holes or spots for realism. Very few leaves in nature are perfect (see Insect Damage, page 66).

MATERIALS LIST

paints
- Cadmium Yellow
- Chromium Oxide Green
- Burnt Umber
- Hooker's Green
- Ultramarine Blue
- Titanium White

brushes
- bright (synthetic): no. 6
- round (synthetic): no. 4

other
- airbrush
- latex mold rubber or other frisket

bark

Tree bark comes in a variety of textures. Therefore, there is no single method that works for every situation, but you can adapt this sponge-texture technique to many of them.

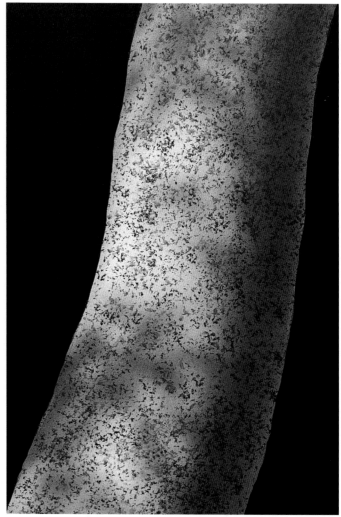

1 LAY IN A SOLID BASE COLOR
Paint your base color, a mixture of Burnt Umber, Ultramarine Blue and Titanium White, over the bark area with a no. 10 bright. This base color should be in the middle range of value, between your darkest shadows and brightest highlights. If you are doing an entire tree trunk, now is the time to give it form by adding shading. Use the airbrush to add the shadows with a mixture of Burnt Umber and Ultramarine Blue. If you are going to have dappled light on the trunk, as in this demo, now is the time to paint in the shadow shapes with the airbrush.

2 ADD A BASE TEXTURE
Put in the base texture coat with the sponge technique (see the Moss demo page 52), using the Burnt Umber-Ultramarine Blue mixture. Study the type of bark you want to create to determine what kind and how much texture to add. If it is a smooth-barked tree, use a thinner mix of paint in the sponge. If it is a heavily textured bark, use a heavier, darker paint mixture. Remember, you don't want to cover up your base color and shading. Just dab on enough paint to "texturize" the base coat.

MATERIALS LIST

paints
- Ultramarine Blue
- Burnt Umber
- Titanium White
- Ivory Black
- Cadmium Yellow

brushes
- brights (synthetic): no. 4, no. 10
- round (synthetic): no. 4

other
- airbrush
- natural sponge

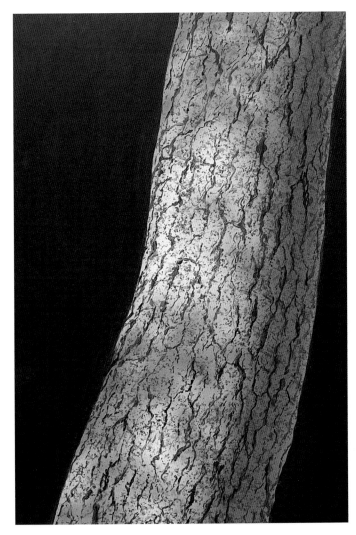

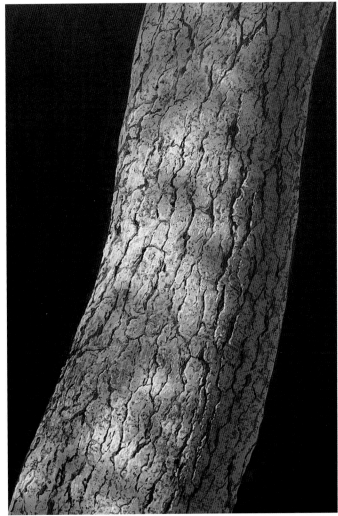

3 DEVELOP THE BARK DETAIL

When the texture coat is dry, paint in the shapes of the bark flakes and cracks using a no. 4 bright and the same mix you used to texturize. Then work darker details in the deeper cracks and holes with Ivory Black using your no. 4 round. Use the sharp corner of your bright brush for the smaller details, and the whole flat for shading in larger areas. Use a random twisting motion as you draw a line with the brush to vary the width.

4 ADD HIGHLIGHTS

Paint in your highlights using your base color mixed with a small amount of Titanium White. To prevent your color from going chalky, add a tiny amount of Cadmium Yellow or Yellow Ochre to the sunlit areas, or blue to the base-color mix for the shadow areas. If you have direct sun on your bark, emphasize the highlights and shadows with greater contrast. When working in areas of dappled light, don't paint harsh highlights all the way to the edge of the lit area. Let the light fall off gradually toward the edge to give it a soft appearance.

wood

The texture of dead or weathered wood can be done with a technique very similar to the one used for doing bark texture.

1 LAY IN THE BASE COLOR
Wood that has been exposed to the weather takes on a silvery color that you can reproduce with grays, grayish browns or blue-grays. Paint in a middle-value color as a base with a no. 10 bright, using several coats of a mixture of Burnt Umber, Ultramarine Blue and Titanium White to achieve an even color.

2 ESTABLISH THE FORM
If the wood you're doing has a rough texture, add a texture coat with a sponge as you did for bark (see page 48). If it is relatively smooth, go ahead and shade the wood form with the airbrush or glazes using a mix of Burnt Umber and Ultramarine Blue (with no white).

MATERIALS LIST

paints	brushes	other
• Burnt Umber	• bright (synthetic): no. 10	• natural sponge
• Phthalocyanine Green	• round (synthetic): no. 3	• airbrush
• Acra Violet		
• Ultramarine Blue	• fan brush (natural bristle)	
• Titanium White		
• Ivory Black		

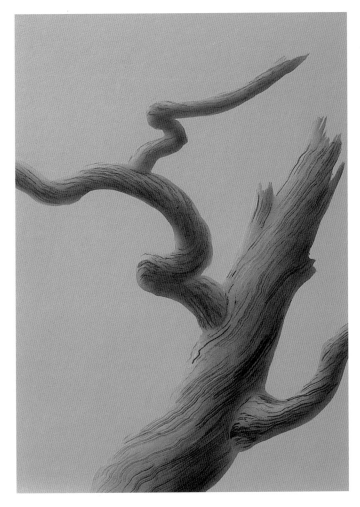

3 PAINT IN THE WOOD GRAIN
Load a natural-bristle fan brush with a Phthalocyanine Green-Acra Violet mixture or Ivory Black, and lightly drag the loaded brush over the wood form, creating the wood grain. Be sure to have good reference material for this: Wood grain can be more complex than you think. Wood grain is not usually just straight, parallel lines. Look at some natural driftwood; observe the way the grain spirals and swirls and how it relates to the shape of the branch or trunk.

4 ADD HIGHLIGHTS AND DETAILS
Add Titanium White to the base color of Burnt Umber and Ultramarine Blue, and then use a detail brush like a no. 3 round to paint highlights on the wood grain. Using Ivory Black or another dark, create small details like wormholes, cracks and other imperfections.

moss

Moss provides a wonderful soft texture and a great background for many creatures.

MATERIALS LIST

paints
- Phthalocyanine Green
- Acra Violet
- Ivory Black
- Hooker's Green
- Cadmium Yellow

brushes
- brights (synthetic): no. 4, no. 6
- old, splayed bright: (synthetic) no. 6
- fan brush (natural bristle)

other
- natural sponge

1 CREATE THE BASIC SHAPE AND BACKGROUND

Be sure to study growth patterns of actual moss: It grows in special environments, not just anywhere. If you want to create believable paintings, they have to be true to nature.

Using a very dark mixture of Phthalocyanine Green and Acra Violet, or Ivory Black, paint the shape of your moss patch, making sure that you give the edge some texture. Use your no. 4 bright to fill in the shape and the fan brush to texturize the edge.

2 ADD A BASE TEXTURE

After you have the ground color filled in, mix a base texture with Hooker's Green and a little Cadmium Yellow. You may want to vary the color depending on the lighting situation you are creating—warmer for sunlit moss and cooler in shadow.

Mix your moss green with water until it is still opaque but watery. Load your sponge or an old brush with paint and dab it a few times on a clean space on your palette until you are getting a satisfactory texture (a brush will take longer than a sponge, but will appear more realistic). You don't want too much paint, just enough to leave a good texture. Begin laying in the moss on your dark ground, but be careful to just touch the sponge or brush lightly onto the surface. If using a brush, lift up as you pull away from the canvas, using your fingers to control the brush, to create a grasslike stroke that is tapered toward the tips. Leave some black space in your texture. If you cover the dark completely, it will appear flat. To avoid creating a repetitive pattern, twist your wrist around randomly as you dab on the paint.

3 ADD HIGHLIGHTS

Use the moss stroke to apply the highlights to the moss as you build its topography (lumps and bumps). Mix greater amounts of Cadmium Yellow to Hooker's Green as you need to brighten the moss color. For a very bright sunlit moss highlight, mix a tiny amount of Phthalocyanine Green with Cadmium Yellow. Because these colors are transparent, you'll need to keep the paint very thick as you add highlights.

Because the moss is attached to the ground or other substrate, be sure to paint the dead leaves, etc., as if they were lying on top of the moss. Just extend a few leaf edges or other debris over the moss edge. It might help to add a leaf or bits of debris on top of the moss.

Creating the Moss Edge

Adding Moss Highlights

lichen and molds

Lichens and spots of mold are everywhere in the natural environment, from the Antarctic to the rainforest. Trees and rocks are great places to put lichens, and they can make a great graphic element in the composition.

Lichens come in all sorts of colors. The United States' desert southwest has lichens that are bright yellow and orange, and its southern swamps have trees that sport bright red patches (that's how Baton Rouge, LA, got its name). However, the most common colors are grayish-green to white. They grow in a circular form, but the circle of growth can bulge in spots, or grow in concentric circles. Some lichens have a leafy growth habit; others look like they were painted on. Try to observe the lichens that grow in the environment you are painting. Take good close-up photos, or collect loose pieces of bark or rocks with lichen growths to use as models.

1 CREATE SKETCH AND PAINT FORM
Sketch out the lichens on the tree trunk in chalk. Be sure to pay attention to the proper perspective for the lichens, which will change as they disappear around the trunk.

Mix Chromium Oxide Green, Titanium White and a little Raw Umber. Keep it in a middle value, and paint in the form of the lichen using a no. 3 bright. This type of lichen has a leafy edge, so paint little bulges moving out from the overall shape, around the edge of the lichen.

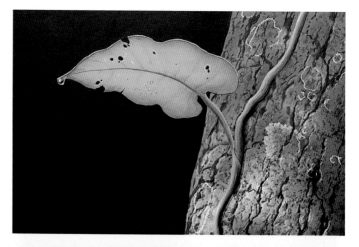

2 LIGHTEN EDGES AND ADD SHADOWS
Add some Titanium White to the base color and use a fine no. 3 round sable to edge the lichen. The lighter edge color should fade into the darker base color toward the center of the lichen. To accomplish this, you can paint a little and then smear the edge of the wet paint with your finger toward the center.

Add some dimensionality to the lichen by painting a very fine black line under the edge of the lichen shape, and under any texture where it seems appropriate.

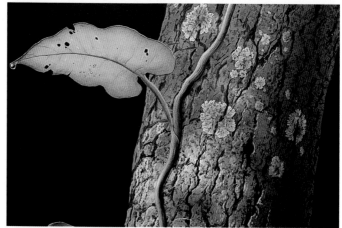

Lichen detail.

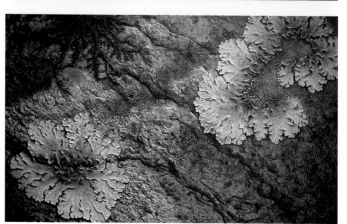

MATERIALS LIST

paints
- Chromium Oxide Green
- Raw Umber
- Titanium White
- Ivory Black

brushes
- bright (synthetic): no. 3
- round sable (natural): no. 3

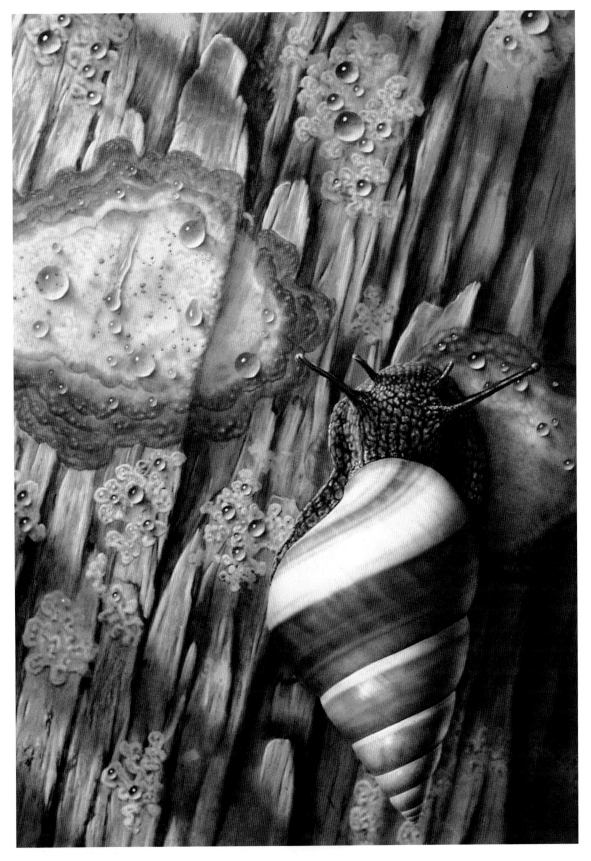

Florida Tree Snail
20" x 15" (51cm x 38cm)
Acrylic on illustration
board

stone

Just as with wood, bark and leaves, there are many kinds of stone textures. Here we deal with pink granite, but you can adapt the technique in this demo to other types of stone.

One very important thing to start with is good reference material. When you try to invent stone, it invariably looks unconvincing.

You may think of stone as being of a certain generic texture and form, but different types of stone have their own unique appearance, just as do different kinds of animals or plants. Don't let your stone look like a pillow or a brick!

1 LAY IN A BASE COLOR
Determine the basic ground color of your rock. Mix a middle value and coat your sketched form until it is an even color. Because we are doing a pink granite, this color was mixed from Red Oxide, Yellow Ochre, Ultramarine Blue and Titanium White.

2 SPONGE IN ROCK GRAIN
This granite has a speckled appearance, so sponge on flecks of dark (Burnt Umber-Ultramarine Blue mix) and light (add Titanium White to the base color) colors in two separate layers using a very light touch. An alternative to using the sponge for flecking is a spatter technique using a toothbrush or stiff-bristled brush (see Sand, page 58).

MATERIALS LIST

paints
- Red Oxide
- Yellow Ochre
- Burnt Umber
- Ultramarine Blue
- Titanium White

brushes
- brights (synthetic): no. 3, no. 4
- round (synthetic): no. 4
- round sable (natural): no. 3

other
- airbrush
- natural sponge
- old toothbrush

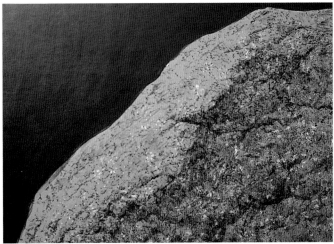

3 ADD SHADOW TO THE ROCK

You can sometimes mix an effective shadow color by adding blue or purple to your base color, but if this isn't feasible, try an Ultramarine Blue-Burnt Umber mix, or Ivory Black mixed with Ultramarine Blue. Make the shadow deepest near the edge of the sunlit area. Airbrush or glazing works well for shadowing, but if you need a distinct shadow line, avoid the airbrush at the edges and use a no. 3 bright instead.

4 DEVELOP THE ROCK STRUCTURE

Using the darker texture mix from step 2, take a no. 4 bright and sketch the structure of cracks and other shapes into the rock. When adding these finer texture details, try following the texture you made with the sponge. Using your imagination, you can see raised and lowered areas in the sponged texture. Use a no. 4 round brush to add to the lights and darks created by the sponge.

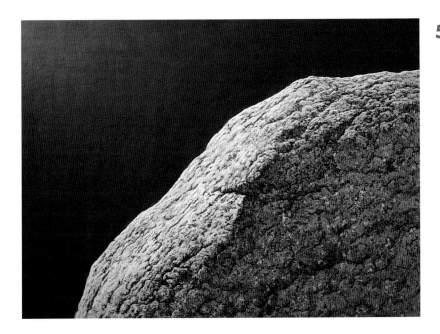

5 ADD HIGHLIGHTS

Add Titanium White to your base color mix and work in the highlights where needed using a no. 3 sable. For brightly lit areas, use a mixture of Titanium White and Yellow Ochre.

sand

Sand is a "fun" texture to do. The basic splatter technique is a little messy, though. To do the splattering, you can follow the "low-tech" method, using an old toothbrush, or the "high-tech" version using an airbrush adjusted to create splatter patterns.

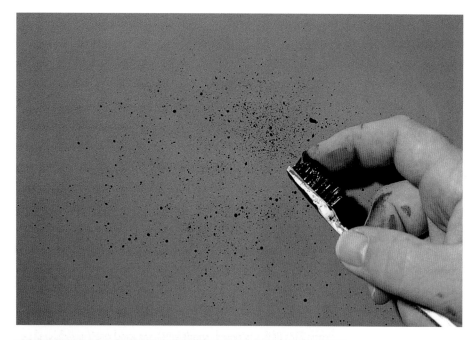

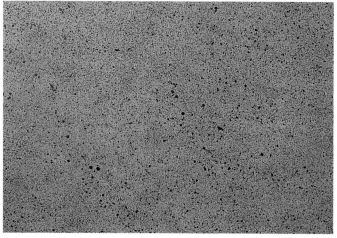

1 LAY IN THE GROUND COLOR AND DARK BACKGROUND

For your typical tan to brown sand, start with a neutral value mix of Raw Umber, Titanium White and a little Yellow Ochre. Cover the sand area with an even coating using a no. 10 bright.

Over the ground color, use a mixture of Burnt Umber and Ultramarine Blue thinned with water to a thin gravy-like consistency. Take an old toothbrush or a stiff-bristled brush, dip it in the paint and then rub your finger over the bristles, causing them to splatter fine droplets over the canvas. It will take a little practice to achieve the proper droplet size: If they are too big, your paint may be too thick or the brush may be too heavily loaded. Keep splattering the area until you have covered about 75 percent of the ground color. You want the overall color to go darker, but you don't want to completely hide the ground color. Wear a rubber glove if you don't want your finger and nail stained with paint.

MATERIALS LIST

paints
- Titanium White
- Raw Umber
- Burnt Umber
- Ultramarine Blue
- Yellow Ochre
- Ivory Black

brushes
- bright (synthetic): no. 10
- round (synthetic): no. 4

other
- airbrush
- old toothbrush

2 ADD HIGHLIGHT LAYER

Splatter on a layer of lighter sand color mixed from the ground color plus Titanium White and Yellow Ochre. Use only enough Yellow Ochre to keep the color from going chalky. In this layer you can begin to suggest a little surface relief on the sand, such as sand ripples. Do this by building up the light color in the areas you want to make into ripples.

3 ADD DETAILS

Use your no. 4 round to add bits of surface detail. Add a tiny line of Ivory Black under some of the larger blobs of the light-colored layer. You can also add bits of even lighter color to suggest bits of shell fragments (if this is beach sand) or larger sand grains. Add a shadow line under these too. If you want strong sunlight on your sand, you'll need to emphasize shadows and highlights.

4 ADD SHADOWS

Using the airbrush, glazes or washes of a dark color such as Ivory Black plus Ultramarine Blue, add faint shadows to enhance features such as ripples in the sand to establish some topography.

dirt

Dirt is one of those textures that varies considerably depending on the consistency of the dirt, the color, etc. However, the basic technique shown here can be adapted to whatever you need. This will get you started.

1 PAINT BASECOAT AND TEXTURE

There are a number of different approaches you could take to starting the dirt. You can work over a neutral-value background and add a darker texture coat with the sponge, or you can start with a dark ground color and use the sponge with a lighter coat. Either way, lay down an even coat of your overall dirt color with a no. 10 bright. Here we've used a middle-value background color of Red Oxide, Yellow Ochre, Titanium White and Burnt Umber.

The trick to adding texture and depth is to use the sponge to begin painting a surface topography in addition to a texture. To do this, mix your texture from Burnt Umber and Ultramarine Blue, load the sponge and make short, horizontal strokes, dabbing in more texture where needed. Don't cover all of the horizontal strokes when you work back over them.

2 DEVELOP SURFACE TOPOGRAPHY

In this layer you are working in a dark color to create the shadows and surface texture, giving your dirt perspective. Using your no. 4 bright, begin sketching in the shadows of surface features on the dirt with a Burnt Umber-Ultramarine Blue mix. Create little bumps, lumps or gullies.

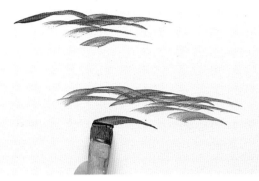

Curved Dirt Stroke

3 ADD HIGHLIGHTS

Using the no. 4 bright, mix a lighter value from the middle value of your dirt. If you started with a dark ground, use the lighter texture coat paint. If you started with a neutral-value ground, mix that with some Titanium White and a little Yellow Ochre.

Try making little curved strokes with the flat, starting at the corner of the brush and then using the whole edge as you round the top of the curve (see detail photo at right, top). Work from the most distant areas toward the front, creating the surface with these strokes. Work with your texture coat and shadows, building up the areas that naturally appear to project upward.

4 ADD SURFACE DETAILS

Add little lumps and grains, using your no. 4 round to create a highlight and then a tiny shadow line under it. Try using an old toothbrush to splatter on (see Sand, page 58) a light coat of dark (Ivory Black) and light (highlight color). You don't want to make it look like sand, just a little grainy. You can add a shadow line under the larger light-colored blobs from your splattering.

If your dirt looks too lumpy, you can drybrush a little of your highlight color over large areas of the dirt. The idea is to diminish the deepest dark colors, reducing the shadows and flattening the surface. Add some grains and debris over this.

mud

Mud is constructed in a similar way to dirt, but the effect here should be a bit smoother, with a wet look. Again, the surface characteristics of mud can vary considerably depending on consistency, color, etc. Use good references, and determine the type of surface texture appropriate for the scene you are creating.

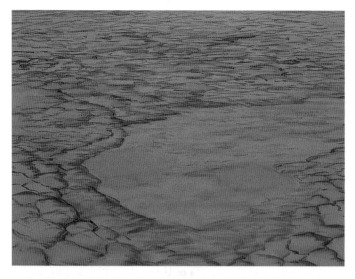

1 PAINT BASE COLOR AND SURFACE TEXTURE

The color of your background or base color will determine the general color of your mud. Determine what color it will be from your reference or according to the needs of your painting. In this demo, the background is mixed from Red Oxide, Yellow Ochre, Titanium White and Burnt Umber, and is sponged on. The type of mud we are creating here has dried and flooded several times and has a surface made of polygonal lumps. Mix a darker color with Burnt Umber and Ultramarine Blue and begin defining the surface using your no. 4 bright. Make curving strokes like a little flattened half-moon shape. You can smooth out your strokes with a little wipe of your finger after every two or three strokes.

2 BUILD THE SURFACE

Mix some Titanium White and a little Yellow Ochre to your base color. Use a curving stroke with your no. 4 bright to put light on top of the lumps in your mud. If the mud looks too lumpy or the cracks are too well-defined, smooth them out by brushing on a wash of the light color. Control the thickness and edges by doing a little finger painting.

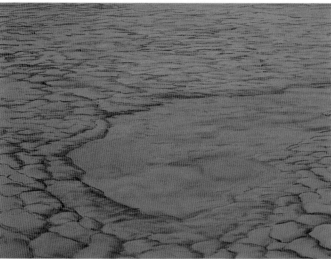

3 MAKE THE MUD LOOK WET

Add some bright highlights mixed from Titanium White and a little Ultramarine Blue (tone it down with a little Burnt Umber if it looks too blue), and add bright highlights too make the mud look wet and shiny. If there is standing water in your mud, edge the water with a broken line or spots of the bright highlight color.

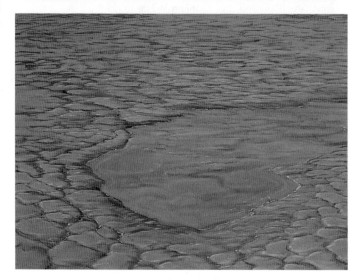

MATERIALS LIST

paints
- Red Oxide
- Raw Umber
- Burnt Umber
- Yellow Ochre
- Ultramarine Blue
- Titanium White

brushes
- bright (synthetic): no. 4
- round (synthetic): no. 4

other
- natural sponge

flowers (hibiscus)

Flowers offer a chance to add some brilliant color to an otherwise drab, earth-toned painting. However, the textures of flowers can be challenging when working with a close-up. For this demonstration I chose a large hibiscus bloom from my garden, because it has a soft, silky texture.

1 ESTABLISH FORM AND COLOR
Sketch in the shape of the flower or transfer a sketch to the canvas. For this pink hibiscus, use Naphthol Red or Acra Violet. The pure color, thinned and sprayed on with an airbrush, is a good start. If you are brushing the color on, add a little Titanium White to the red or crimson to keep it in the correct color value.

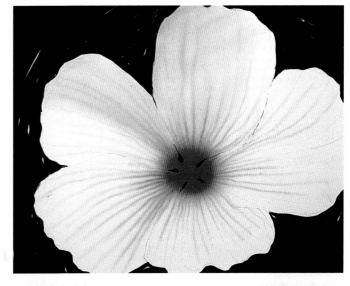

2 ADD FORM WITH SHADOWS
Mix some Dioxazine Purple or Ultramarine Blue into the red to make a shadow color, and airbrush or drybrush the shadow areas in. Mask the edges and spray the shadow color on where edges of petals overlap, creating shadows. This creates a crisp line on the upper petal, and a good illusion of shadow underneath. Remove the masking before doing any more spraying on the petal with the masking. Add shadow to the ribbing in each petal. Work with the airbrush very close to the surface in order to get a small line.

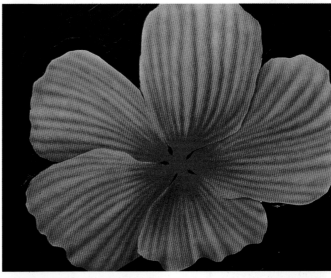

3 ADD HIGHLIGHTS
This can be a two-step process, depending on the amount of detail you need. For this demonstration, add a layer of light pink highlights with the airbrush, and then layer an even brighter pink with your no. 2 sable, painting all the way to the edges and creating vein structures in the petals.

Add details like the stamen and pistils last. Use a light pink mixed from Naphthol Red and Titanium White to do the basic structure with a no. 3 sable. Add some Cadmium Yellow to the mix and add the stamens with their pollen tips.

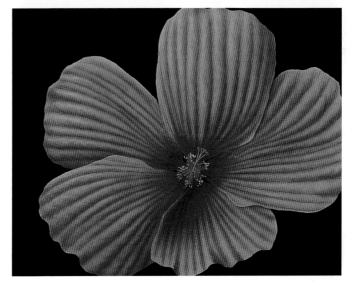

MATERIALS LIST

paints
- Acra Violet
- Cadmium Yellow
- Naphthol Red
- Dioxazine Purple
- Ultramarine Blue
- Titanium White

brushes
- round sables (natural): no. 2, no. 3
- round (synthetic): no. 6 (use an old one to apply latex frisket)

other
- airbrush
- latex mold rubber or other frisket

water drops

A clear drop of water acts like a tiny magnifying lens. Whatever lies behind it is distorted and enlarged. When a drop is hanging from a tip of a leaf or clinging to a spider's web, it forms a sphere and, as a spherical lens, inverts the image of whatever is behind it. For instance, if there is a landscape behind the drop, you'll see the sky in the bottom portion of the drop and the land at the top.

The light that passes through the drop is refracted, so the shad-

ing is the reverse of what you would expect in a solid, opaque object. The dark shading is on the same side as the highlight.

Drops of water clinging to the tip of a leaf or dripping down the side of an object add a sense of humidity or wetness to a painting. They are fascinating little jewels. They take a minimum of effort and add a great deal to the mood of a painting.

1 OUTLINE THE DROP
Draw in the shape of the drop and, if you will be airbrushing the shading in, as in this demo, apply masking around the drop.

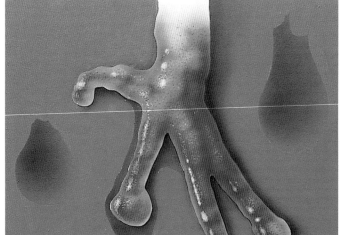

2 USE THE AIRBRUSH TO PAINT THE DROP
Because this drop is on a green leaf background, the shading in the drop should be a darker value green. Mix Hooker's Green with Ultramarine Blue and a little Burnt Umber to tone the color down a bit. Airbrush in the shading, making the highlight side darkest.

3 ADD A LIGHTER VALUE BACKGROUND
Mix a little Cadmium Yellow and Titanium White to the background color (here it is Chromium Oxide Green) and spray it in along the bottom edge opposite the highlight. It should be applied in a thin crescent along the edge.

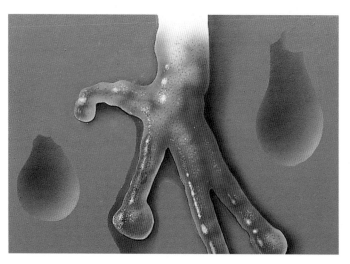

MATERIALS LIST

paints
- Chromium Oxide Green
- Hooker's Green
- Ultramarine Blue
- Burnt Umber
- Titanium White
- Cadmium Yellow

brushes
- bright (synthetic): no. 3

other
- airbrush
- latex mold rubber or other frisket

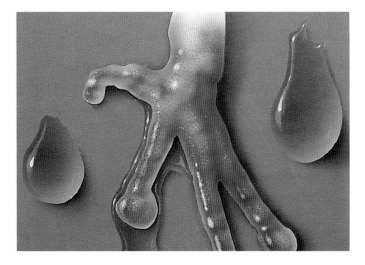

4 ADD SHADOWS AND HIGHLIGHTS

Remove the masking from the outside of the drop and carefully mask over the drop itself. You must be very careful to apply the masking exactly to the edge of the drop. Then spray on a shadow under the bottom edge, exactly parallel to the light crescent you painted inside the drop. The shadow should be darkest closest to the edge of the drop, lightening in value as it goes further away.

For the highlights, mix a little Ultramarine Blue and Titanium White, and use this mix with the airbrush or a no. 3 bright to add a bluish highlight to the sunlit side. Then use pure Titanium White or white with a tiny amount of Cadmium Yellow to make a bright highlight, centering it in the slightly larger blue area. Also, you may want to add Cadmium Yellow and Titanium White to the background color to edge the light area on the underside of the drop. Concentrate the color in the center of the light-crescent area.

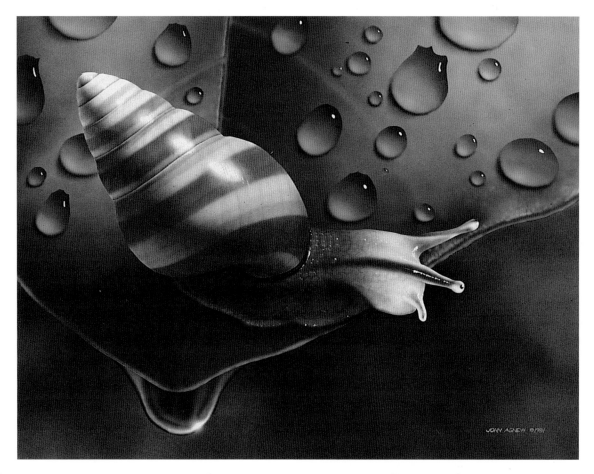

Hawaiian Tree Snail
15" x 20" (38cm x 51cm)
Colored ink and airbrush

insect damage

Leaves in nature are rarely perfect. Insects are always chewing holes and making spots where they suck plant juices. These sorts of blotches, holes and spots of color can add an element of realism, and can become interesting graphic elements in the design of your painting.

Insect damage is fairly easy to do. The place to start is outside, observing the real thing. If you are after total realism you should work from nature, and if you are doing an exotic environment you should research the sorts of insect damage you can see there. Some types of damage are fairly generic, but an entomologist can usually tell you exactly which creature made the spots on a leaf. I don't usually get that exacting...a few holes and discolorations can give the desired effect without attracting criticism about being hokey or unrealistic.

1 PAINT THE DYING LEAF

This leaf is backlit, so the colors of the spots should be very warm. Sunlight coming through a leaf makes it glow with warm colors. Yellow Ochre and Cadmium Yellow make great colors for leaf spots. Just make them brightest in the very center of the spot. Sometimes you may want to add a spot of Burnt Umber in the center of the yellow. As a spot ages or enlarges, the dying leaf tissue becomes bright yellow. As the tissue dries out, it turns brown. Work with very thin paint when doing these effects; since you want the edges soft, start with a thin layer of paint and build it up in the center.

2 PAINT THE HOLES

When painting holes, start with a solid opaque layer of Ivory Black (or whatever color is behind the leaf) and then take a very small brush (no. 3 sable) and edge a side of the hole with a very thin line of Titanium White where it would catch the light. A similar technique is used for torn edges of leaves.

MATERIALS LIST

paints
- Yellow Ochre
- Cadmium Yellow
- Burnt Umber
- Ivory Black
- Titanium White

brush
- round sable (natural): no. 3

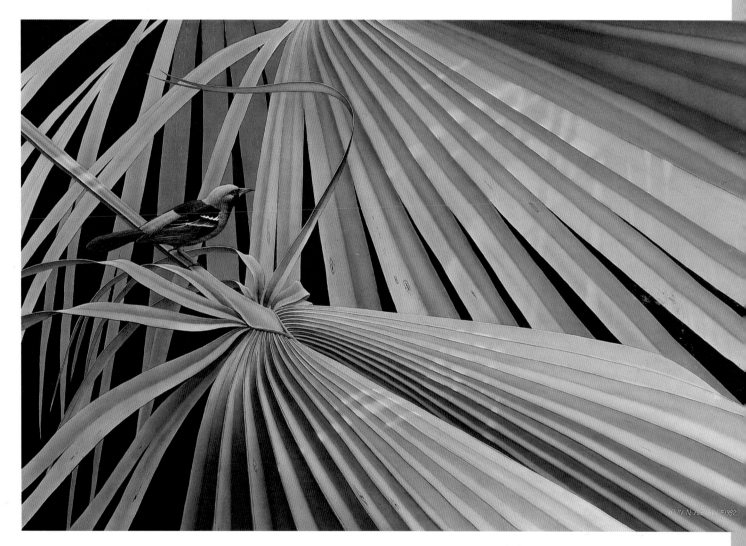

Hooded Oriole
26" x 36" (66cm x 91cm)
Acrylic on Masonite

body of water

Water can be a very complex texture. It ranges from the chaotic waves of a stormy ocean to the mirrorlike surface of a pond. For our purposes, we'll stick to the latter, since we are concentrating on scenes of a small, intimate nature.

Because the water we'll deal with is mostly transparent, what we'll be painting is primarily the reflections on the surface, and how water affects the appearance of objects underneath it. It is essential to have a good water photo reference or to observe directly from nature, because the reflections can be intricate and varied.

1 CREATE THE CREEK BOTTOM AND ROCKS

Here we'll make a pebbly creek bottom. After applying a base coat of Yellow Ochre mixed with Burnt Umber and Titanium White, lay in a texture coat (Bark or Stone demos, pages 48, 56) of Burnt Umber mixed with Ultramarine Blue and Yellow Ochre. You can vary this color scheme as needed.

Use your no. 6 bright and the darker mixture to sketch rock shapes. Water changes the perspective of the objects beneath it, so flatten the shapes of the rocks a bit toward the top. If you plan to have any ripples in the water, you may want to sketch them in with chalk; as you paint in your rocks, bend them a little where the lines of the ripples cross them.

The Perspective of Reflections

A mistake of many beginning artists is to make a reflection perfectly symmetrical with the object being reflected.

To see how the perspective of reflections work, place the fingertips of your two hands together, spreading your fingers apart. Imagine this as a spider sitting on the water.

When you look at the "spider" from the edge it looks symmetrical, but when you turn the spider at an angle, looking at it from above, the spider and its "reflection" begin to look very different.

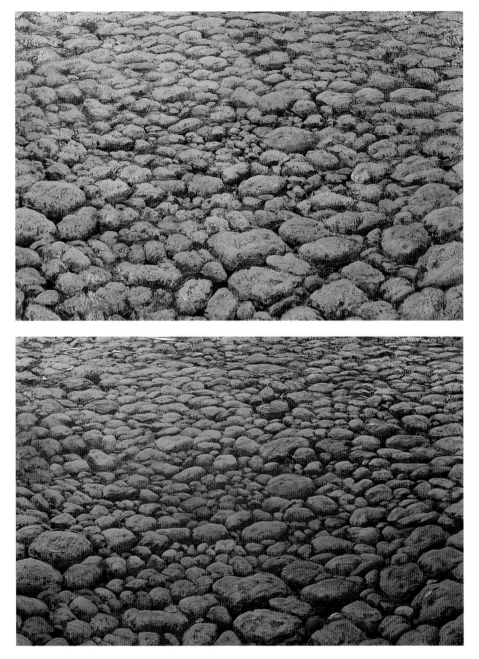

2 ADD HIGHLIGHTS

Mix a little Burnt Umber, Yellow Ochre and Titanium White. Use your no. 6 bright to add a little light to the tops of your rocks. Unless your water is going to be extremely clear, it's probably not necessary to do a lot of detail in the rocks. You can use your finger to smooth out the bottom edges of your strokes where the light paint fades into the shadows on the rocks.

3 ADD COLOR TO THE WATER

Most water has some color to it, and even if the water you are reproducing has none, giving it a little color helps to define it. Mix a little Yellow Ochre with Hooker's Green, and use an airbrush (or glazing method) to color the water area. You'll need to mask off the shoreline and any rocks that protrude from the water. If your water is cloudy, add a little Titanium White to the green mixture, increasing the yellow a tiny bit to keep the white from turning the mixture chalky. Apply this layer a little more heavily in areas of the water that are supposed to be deeper.

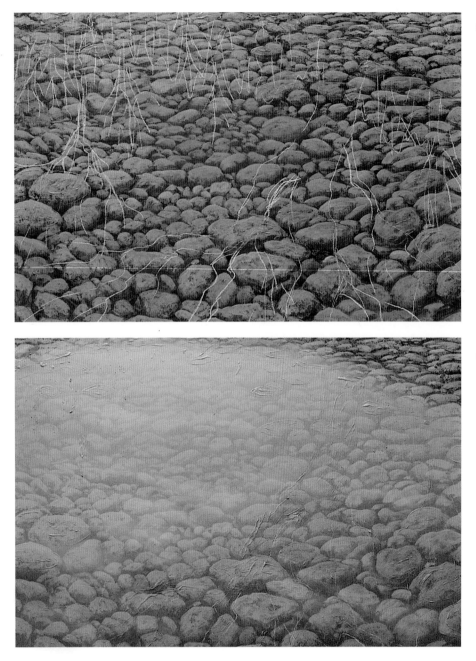

4 MASK OUT TREE REFLECTIONS
Use a piece of white chalk to lightly sketch in tree reflections. Then paint latex rubber mask over the sketched trees.

5 PAINT THE SKY REFLECTION
After the masking is complete, mix a sky color with Phthalocyanine Blue, Titanium White and a little Yellow Ochre. Thin it down for the airbrush and spray it over the reflection area. (This technique works best with the airbrush: Brushing on layers makes the paint too thick to peel away the masking in a neat manner.) To get a nice even coat, try using steady, horizontal strokes with the airbrush. The sky reflection should be brightest toward the top of the water area and get thinner and a little bluer toward the bottom (the reverse of the actual sky).

chapter 4
painting animal textures

The textures of animals need to be a bit more precise than those of the environment in most cases. In fact, to create a realistic animal, textures need to be very precise because every species is unique. If you know birds well, you know that each species has its own type of feathers and that they vary in size, location and number. The same is true of reptiles and scales, and the skin textures of amphibians. This chapter demonstrates how to paint a variety of these textures to create an easily recognizable, accurate animal.

ice

Ice comes in a variety of forms, textures and colors. How you portray it depends on the scene you are painting. Once again, get good references! In this demonstration you'll learn how to do the clear ice you might see in a small icicle.

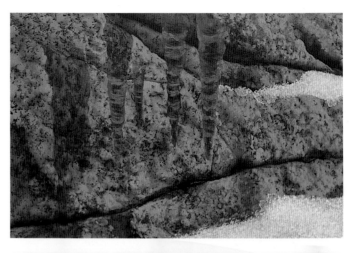

1 LAY IN THE BASE COLOR

There is no base color! In clear ice, the base color is whatever is behind the ice. However, because the ice bends and refracts the light, you need to consider how it will distort the objects behind it. If you plan out your painting ahead of time, you can paint in the distortions as you do the background, but if the icicle is an afterthought, you'll have to add that in.

2 ADD REFRACTED AND REFLECTED LIGHT

When painting ice, most of the light you see is refracted light. The light passes through the ice and is bent toward you. Because of this, the edges of an icicle are often the brightest areas, especially on the edge opposite the sun. On the surface facing you, there will be a little reflected light. As with snow, the color is basically that of the sky. Mix a little Ultramarine Blue with Titanium White and edge the icicle. Use a watered-down mix of the same color to add a little sheen of reflected light on the surface of the ice. Ice that has air or impurities in it will have a milky, translucent appearance. Add the milky color with a no. 4 bright brush or airbrush, and then apply the refracted light and highlights.

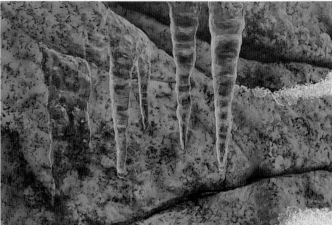

3 ADD BRIGHT HIGHLIGHTS

If there is direct sun on the ice, add a bright white mix (Titanium White plus a tiny amount of Cadmium Yellow) with a no. 3 round sable to the edge of the ice that is opposite the sun. Be sure to observe directly or to obtain good references before doing this. If there is no direct sun on the ice, add Titanium White to the first highlight color and use that instead of a bright white mix. Add a few bright highlights to the surface where they might reflect, but don't overdo it. If there is a water drop at the tip, you can add a bright highlight there as well.

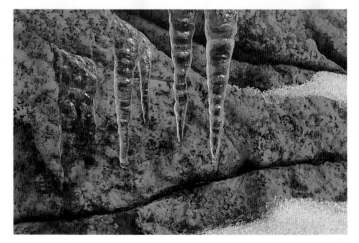

MATERIALS LIST

paints
- Ultramarine Blue
- Cadmium Yellow
- Titanium White

brushes
- bright (synthetic): no. 4
- round sable (natural): no. 3

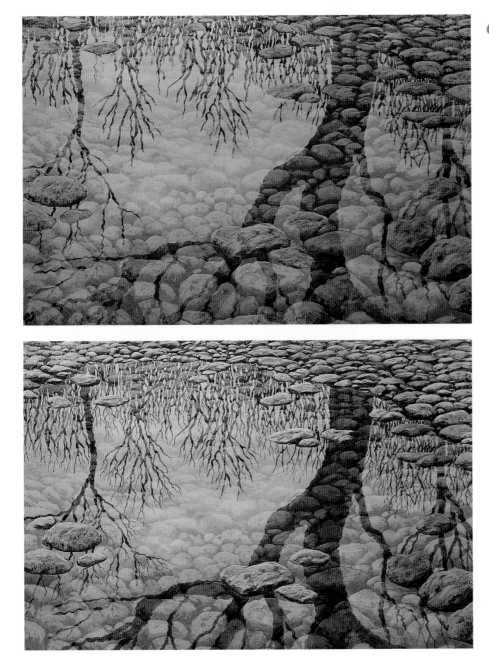

6 PEEL OFF MASKING AND TOUCH UP
After the airbrushing is done, peel away the masking and touch up the tree reflections. The thinner branches or other small details may look a little coarse, so you might need to touch them up with a no. 2 round and paint mixed to match the general color of the water underneath the reflection. My rocks did not stand out enough from the color of the water, so I added contrast by increasing the brightness of the rock highlights and the darkness of the shadows.

snow

You'll find that there is no single texture that describes snow. The best you can do is too come up with a credible illusion, but that is the essence of painting!

From a distance snow looks smooth, like sand. Up close it is a coarse substance, with lots of varying texture that changes with the time of day and the temperature. Because we are primarily focusing on intimate close-ups in this book, we'll take a close look at snow.

1 LAY IN THE BASE COLOR

Snow has no intrinsic color of its own: Its color is based on the color of the sky. On a sunny day, where snow is in shadow, it takes on the blue of the sky, but a bit darker. In direct sun it is a blazing white, or whatever color the sunlight happens to be. Start with a basic blue sky color here—Phthalocyanine Blue, Ultramarine Blue and Titanium White with a small amount of Burnt Umber to tone it down a bit—applied with a no. 10 bright.

2 BUILD SURFACE TEXTURE

Use a natural sponge, old splayed brush or other texturing tool. Depending on the scale of the snow texture, you might want to choose between a coarse-textured sponge or a finely textured one. Mix a little Titanium White to the base color and begin dabbing it on (see Moss or Stone demos, pages 52, 56). Don't go for the brightest highlight yet—that will come in the next step. Do not go too heavy on the pressure. Begin to suggest surface topography, building up the bumps and dips of the snow.

3 ADD HIGHLIGHTS

Build up the brightest highlights. Use the same texturing technique as in step 2, but with a brighter color. To detail the edges or to add detail to the surface of the snow, use a no. 4 round brush to highlight or shadow shapes as needed. Don't use a pure white except in the very brightest sunlit highlights. Adding a tiny amount of Cadmium Yellow to the Titanium White may increase its apparent brightness by contrasting with the blue underpainting.

MATERIALS LIST

paints
- Ultramarine Blue
- Phthalocyanine Blue
- Burnt Umber
- Titanium White
- Cadmium Yellow

brushes
- bright (synthetic): no.10
- round (synthetic): no. 4

other
- natural sponge

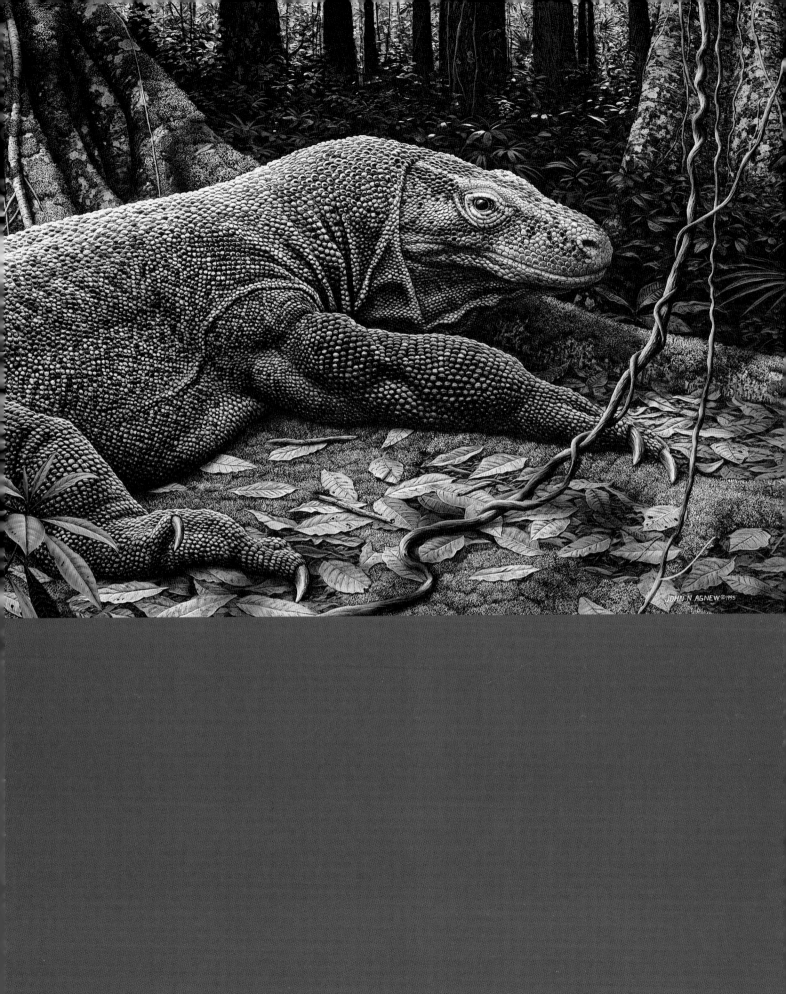

scales

The scales of reptiles are different for each species, but fall into a few categories. Snakes generally have overlapping elliptical scales, but they can be rough or smooth and have widely varying shapes and colors. Lizards tend to have granular or beaded scales, but some can be more like snakes. We'll take a look at a couple of varieties.

Beaded Scales (most lizards)
Most lizards have some variation of beaded scales, although individual species vary. These can be drawn as circles over the ground color, and then shading and highlighting can be added.

Overlapping Scales (most snakes)
Snakes can be identified by an expert just on the characteristics of their scales. Each species has a specific number of rows of scales and a unique pattern of scales on the head. So, it is important to have good references. A live snake is the best reference, but a good set of photos is the next best thing. Preserved specimens are OK for counting scales, but the colors fade in the formalin. Road kills make good references as well.

Plated Scales (crocodilians)
Crocodilians (alligators and crocodiles) have a unique type of scales that resemble flat plates and can be round or rectangular. Some scales even contain bony plates that act as armor. The shape of individual scales varies according to the location on the body. Be sure to use good references.

snake scales

Each scale changes shape with the changing perspective as the pattern winds around the snake's body. In addition to perspective changes and foreshortening, the scales themselves are not all the same size. Also, when the snake bends its body, the scales on the inside of the curves overlap each other even more, and the scales on the outside of the curves stretch apart, sometimes revealing the skin beneath.

1 APPLY A BASE COLOR

Lay down the base color of the snake with your airbrush. If there is a complicated color pattern, try to determine the ground color that underlies the other colors, or find a color that will support the color pattern as an underpainting. Here we are using a mixture of Burnt Umber and Raw Sienna as a base color. After applying the base color, add the color patterns that overlay the base. Here we are using a mix of Burnt Umber and Ultramarine Blue. Be careful to construct the pattern in the proper perspective as it winds around the body. After finishing the color pattern, apply the shadow color (Ultramarine Blue and Burnt Umber) to emphasize the snake's form and give it volume.

2 MAKE A SCALE MAP

After laying out the color pattern of your snake, begin planning out the scale pattern. The most difficult part is getting the right perspective. Draw the scales lightly in pencil first, and when you have them correctly drawn, paint in the edges with darker mix of the darker color pattern color (Burnt Umber and Ultramarine Blue) using your no. 4 round sable.

3 ADD SHADOWS AND HIGHLIGHTS

Paint the scale shadows. Darken the color you used underneath that scale and use it to define the scale's form. If the snake has a complicated color pattern, lighten or darken the color of each differently colored area to use for shadows or highlights. Paint in the highlights on the scales using the no. 4 round sable. Mix the highlight color by adding a little Titanium White to the ground color. Mix in a little Yellow Ochre or Ultramarine Blue (depending on whether you need to make it warm or cool) to keep the highlight color from going chalky.

MATERIALS LIST

paints
• Burnt Umber
• Raw Sienna
• Ultramarine Blue
• Yellow Ochre
• Titanium White

brushes
• round sable (natural): no. 4

other
• airbrush
• latex mold rubber or other frisket

leathery, warty skin

We're not talking elephants here. Since this book is concerned with intimate close-ups more than big animals that live out on the plains, we'll look at smaller animals with this sort of texture, such as reptiles and amphibians, primarily, although many birds also have leathery skin around their face.

For this demonstration, we'll do tree frog skin. Amphibians often have "warty" skin. These warts are actually glands that secrete toxins or mucus that helps to protect them from predators and the elements. The frog we'll be doing doing here is a Gray Tree frog, a species with particularly warty skin. Some people call these a "tree toad." They can change their color like a chameleon.

1 LAY DOWN THE BASE COLOR AND SHADOWS

After sketching out the form of the frog and masking the edges, lay in the base color with Hooker's Green plus Yellow Ochre, using an airbrush because it most easily achieves the soft shading necessary for the frog's texture.

Mix Hooker's Green and Ultramarine Blue plus a little Burnt Umber to use as a shadow color. Use the shadow color and the airbrush to deepen the texture and build the general form with shading. The image here looks blurry because of the airbrush. You'll bring it into sharper focus as you go through the next steps. Remove mask.

MATERIALS LIST

paints

- Yellow Ochre
- Hooker's Green
- Ultramarine Blue
- Titanium White
- Cadmium Yellow
- Burnt Umber
- Phthalocyanine Green
- Acra Violet

brushes

- round sable (natural): no. 4

other

- airbrush
- latex mold rubber or other frisket

2 REFINE THE TEXTURE BY HAND

Use your no. 4 round sable to sharpen the texture details with the shadow mixture used in step 1.

Use a very dark mixture of Phthalocyanine Green and Acra Violet to detail and deepen some the crevices in the skin and underneath the bottom of the frog. This will give the texture real depth—but don't overdo it.

3 ADD HIGHLIGHTS

Use your no. 4 round sable and a highlight mixture made from the base color mix and Titanium White. Add a little Cadmium Yellow to keep it from going chalky. Highlight each bump and other raised areas such as wrinkles. Try to mix a value between the original base color and pure white. Use the pure white for intense highlights that will make the frog look wet and shiny.

eyes

Eyes are one of my favorite things to paint. I often save them for last as a "reward" for sticking it out through all of those tedious scales. Eyes, especially that last little highlight on the eyeball, give life to an animal.

Reptiles and amphibians have fantastic eyes. That's one of the things that attracts me to them. Of course birds and mammals can have beautiful eyes too. When you do close-ups of these animals, the eyes become all-important, and detail can't be skipped if you want to give them a convincing lifelike appearance. As with everything we've painted so far, excellent references are essential. You have to know not only what the animal's pupil looks like in detail, but also what the

wet surface of the eye reflects. I have even seen some artists paint the rectangular reflection of an electronic strobe in the eye of an animal!

pupils

Each species has its own type of pupil, but there are a few generalities we can mention here.

Frogs tend to have a horizontal slit pupil, although when it is wide open in the twilight or dark it appears to be round.

Among the snakes, vipers, boas and pythons usually have a vertical slit pupil. Colubrid snakes, such as ratsnakes and kingsnakes have round pupils, as do cobras

and their allies.

Lizards often have a round pupil like a bird or mammal, although some nocturnal species have vertical or horizontal slits. The type of pupil can affect how the light reflects.

iris

On a frog's or a snake's eye, the iris is close to the surface of the cornea, so the light reflects from the iris as it would from the eye's surface. On many lizard, mammal and bird eyes, the iris slopes inward toward the pupil's opening, so the light reflects more from the bottom edge of the iris than from the top. Be sure to check your references carefully.

Heron eye

Lizard eye

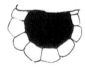

Snake eye

frog eyes

Frogs and toads have particularly beautiful eyes. They also have very complex pupils. The pupils have a lot of texture and a variety of colors and patterns. They can be a challenge to paint, but with patience and careful study of the animals' eyes, you should enjoy it.

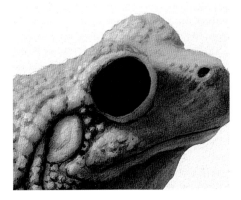

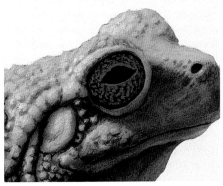

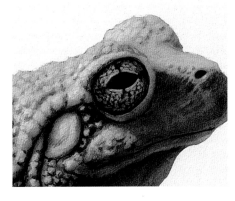

1 DRAW THE EYE
Sketch the eye in place on your animal and paint the eyeball in Ivory Black with your no. 4 round.

2 ROUGH IN THE PUPIL
Determine the base color of the iris area and paint it in with your no. 3 sable, outlining the black area of the pupil. For the iris of this tree frog, use a mixture of Titanium White, Ivory Black and Yellow Ochre in a value between black and a middle value. You will build up the iris with lighter colors in the next step.

3 BUILD UP THE LIGHT
Mix a little Titanium White and Yellow Ochre with the base color of the iris and begin building up the lighter areas, with the top of the iris catching more light than the bottom. On frogs, the iris is close to the surface of the cornea, so the light falls on the iris as it would on a ball.

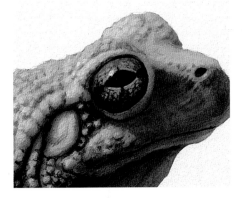

4 FINAL TOUCHES
The tree frog's eye has a slightly golden appearance around the edge of the pupil, so mix more Titanium White and Yellow Ochre with the iris base color and edge the pupil opening. Once this is done, use a little Ultramarine Blue and Titanium White to create a sky reflection on the top of the eyeball. Frogs have unusually clear corneas, so do not overdo this. A tiny dot of pure white puts the finishing touch on the reflection. Add a few white highlights around the edge of the eye to give it a wet look.

MATERIALS LIST

paints
- Ivory Black
- Titanium White
- Yellow Ochre
- Ultramarine Blue

brushes
- round (synthetic): no. 4
- round sable (natural): no. 3

translucent flesh

Many small animals have translucent flesh. Small frogs, mollusks and other creatures have flesh that transmits light. Painting this effect convincingly is not difficult, but I find the airbrush makes this one a lot easier.

Translucent flesh transmits light in a way similar to a water drop, but the tissue scatters light internally instead of just letting it pass through. The edges of the body appear outlined in light, and the edge opposite the light source appears brightest. Look at the way a water drop behaves in the light and compare it to a frog's toe.

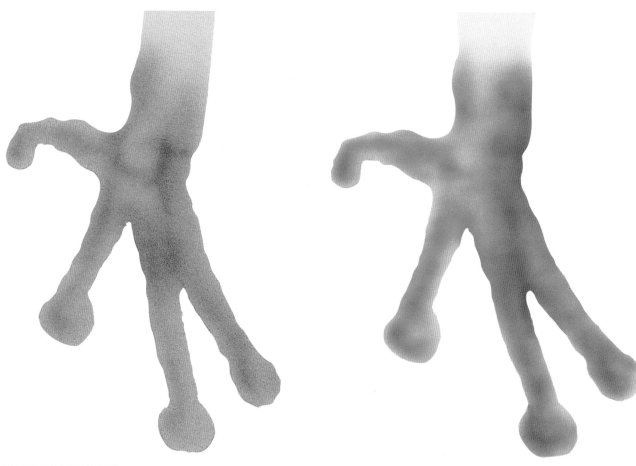

1 PAINT THE BASE COLOR
For this demonstration, complete a simple line drawing of a frog's foot. Mask off the drawing and airbrush in the base color with a mixture of Burnt Umber and Yellow Ochre. You can do this without the airbrush, but the airbrush will give a smooth gradation.

2 ADD DEPTH TO THE FLESH
Add more Burnt Umber and some Ultramarine Blue to the base color and use your airbrush to create shadow within the tissue. The darkest areas are beneath the same places where you will later highlight the surface.

MATERIALS LIST

paints
- Burnt Umber
- Ultramarine Blue
- Yellow Ochre
- Titanium White
- Ivory Black

brushes
- round sable (natural): no. 3

other
- airbrush
- latex mold rubber or other frisket

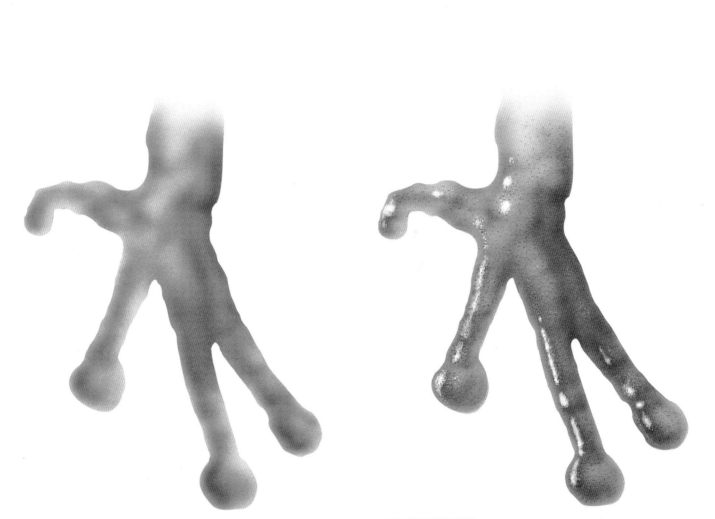

3 ADD SHADOWS AND SURFACE TEXTURES

Surface texture is essential for the illusion of translucent tissue. It defines the surface and gives the impression of there being something underneath.

You can achieve this by using some of the shadow mix from step 2 and a very small brush (a no. 3 round sable) to create the tiny shadows of the little bumps in the skin. Tiny crescent strokes work well.

Add highlights to the bumps by mixing Titanium White into the base color of step 1 and use the no. 3 round sable to add a touch to each bump. Make sure the highlight mix is only slightly brighter than the base color.

4 ADD HIGHLIGHTS

Mix Titanium White with the base color until it is close to a pure white, thinning it to an almost watery consistency. Use the no. 3 round sable and a drybrush technique (with nearly all the color squeezed from the brush) to apply some dim highlights. Then apply a nearly pure white thick enough to be very bright in just those few spots where you need bright highlights.

smooth fur on small mammals

As an artist who specializes in reptiles and amphibians, I don't consider myself an expert fur painter. Nevertheless, it can be approached in much the same way we have approached other textures.

The type of fur your subject has will determine the approach you take. Mammals with thick fur have clumps and furrows in the fur texture. Short fur may not exhibit these textures, but might appear to be smooth and shiny. These differing types of fur would require different approaches.

There are as many ways to do fur as there are artists. Many mammal painters use an airbrush to develop the forms of the animal as a whole and the forms within the fur. Then the details of individual areas are added by hand. When working by hand with a brush, the approach is generally the same, constructing form and then adding details. Some painters prefer to do fur by starting with a dark base color and then building the fur with lighter and lighter colors. Others start with a middle value and add shadow and highlight. This is the approach we'll take with short fur.

1 PAINT THE BASE COLOR
After sketching in the shape, paint in the ground color for the chipmunk using a Yellow Ochre and Titanium White mix and your airbrush. Your pencil sketch should be barely visible under this base coat.

2 ROUGH IN THE COLOR PATTERN AND FORM
Use your airbrush or a no. 4 bright and a mix of Burnt Umber and Ultramarine Blue to create a dull, dark brown. This lays the groundwork for the basic color pattern and some shadow to delineate the form of the chipmunk.

3 DEVELOP THE FORM
Use a little straight Burnt Umber to color in some darker brown where necessary on the color pattern.

MATERIALS LIST

paints
- Yellow Ochre
- Burnt Umber
- Ultramarine Blue
- Ivory Black
- Titanium White

brushes
- bright (synthetic): no. 4
- round sable (natural): no. 3

other
- airbrush

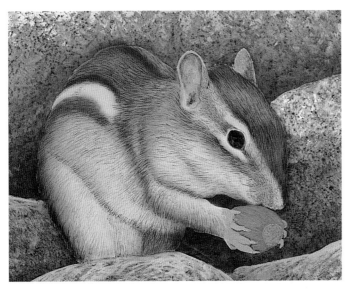

4 **BEGIN THE FIRST LAYER OF HAIR**

If you take a close look at a chipmunk, you'll notice that there are layers of differently colored hair on its body, with darker hair underneath and lighter hair on top. Start with the darkest hair, and use a tiny detail no. 3 round sable to carefully lay in the fur, stroke by stroke, using Burnt Umber dulled with a tiny amount of Ultramarine Blue. Thin this mix to a watery consistency, and don't load the brush very much. You need to create a true "hairline."

This isn't quite as tedious as it sounds, especially on a small mammal like this. It's a bit like shading with a pencil. Just make sure that you pay attention to the direction the fur grows and do your strokes the same way. Also note any areas where the fur clumps together and recreate these with the dark color.

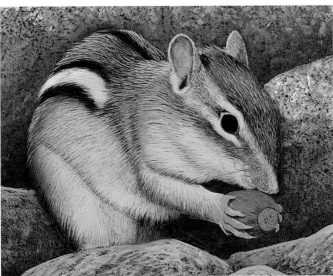

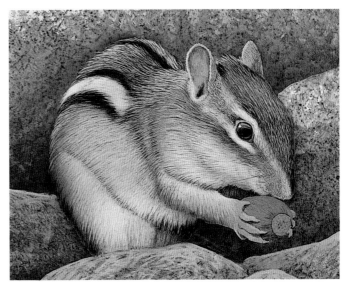

5 **ADD A LAYER OF LIGHTER HAIR**

Mix a little Titanium White with the base color of step 1 and begin adding the lighter fur. Keep this mix pretty thin too. You are doing highlights, so add the light on top of areas in the darker strokes to create a three-dimensional effect. Build up the areas of clumped fur and create lighter hairs that extend a little into darker shadow areas. At the same time, deepen some of the darks between the fur clumps and add some darker contrast around the highlights. Use the dark Burnt Umber-Ultramarine Blue mix from step 2 for this.

6 **ADD THE FINAL, LIGHTEST LAYER**

Add an even lighter layer of hairs, this time mixing a near-white color. If you are working in shadow areas and don't want that bright a value, you can darken this light color with a Burnt Umber-Ultramarine Blue mix. Work in the areas of white fur on the animal and those places where there are tiny light hairs on top of dark ones. You can add highlights to the fur where necessary.

After finishing the final layer of hair, you might want to come back with Ivory Black or another very dark mix and add detail to the edges of the animal and deepen some of the shadows in the the depths of the fur. Add other details such as the eyes, whiskers and toes.

shaggy fur on large mammals

Doing fur on bigger mammals requires a little more planning than the small mammals. Because the fur is very thick, it has patterns of clumps and partings that aren't usually visible on short-furred mammals like the chipmunk. The polar bear has thick fur that has a complicated topography, and consequently makes a good subject for this demonstration.

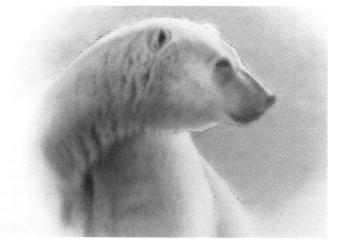

1 SHADE FOR FORM AND FUR DETAILS

Draw out the animal, mapping out the entire topography of the fur: all the creases, cracks, clumps and lumps.

Using the airbrush or the no. 6 bright, begin shading the animal, in this case with a mix of Ultramarine Blue and a little Burnt Umber. If you are doing the shading with a no. 6 bright, thin the paint to a watery consistency. Give the texture of the fur special attention, building volume in the clumps and partings with the shading. Darken the entire animal a bit so that you can build highlights on top of the darker base. Darken the deep spots in the fur even more. If you are shading with the airbrush, the animal will look a bit out of focus at this stage.

2 DEEPEN THE FUR SHADING

Using the flat and a no. 4 round to darken the partings and other deep areas of the fur. With the polar bear, you don't want to get overly dark, as you want to retain the impression of "white" fur. A polar bear's fur is not white, really, but a creamy yellow color. There will be very little pure white in the fur when you're done.

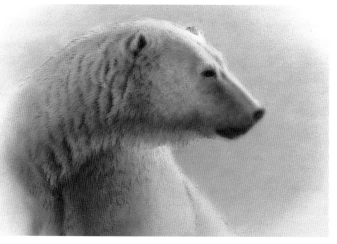

3 ADD HIGHLIGHTS

Highlight the fur with a Titanium White-Yellow Ochre mix using the no. 4 round. Mix the paint thin but not watery, and form a sharp tip on the brush to make the fine hairs of the fur. Highlight clumps between your dark strokes to emphasize the depth. Much like drawing, controlling the density of these lines controls the brightness of the highlights.

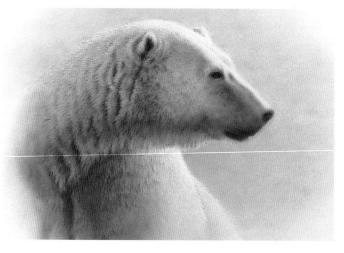

MATERIALS LIST

paints
- Yellow Ochre
- Burnt Umber
- Ultramarine Blue
- Titanium White

brushes
- bright (synthetic): no. 6
- round (synthetic): no. 4

other
- airbrush

feathers on a vermilion flycatcher

As a texture, feathers are something between scales and fur. Each feather has its own form and shading, plus the texture of each barb of the feather on top of that. They make one of the most difficult and interesting textures to paint.

Like the scales on a reptile, every species of bird has its own unique pattern of feathers. To do a bird properly, you need to research the feathers carefully. Sometimes photos just cannot provide enough detail, and it becomes necessary to have a "bird in hand." Universities and natural history museums often have collections of stuffed birds that you can inspect on the premises and sometimes borrow.

Doing close-ups of small birds accurately demands an exacting technique, good brushes and good references. For this demonstration I used a study skin of a Vermilion Flycatcher (borrowed from a museum), which gave me all the feather detail I could want, although the body shape was distorted. Photos and field sketches of living birds are necessary for accurate posture and proportions. It can be tedious to try to paint every barb on every feather, but you can give the impression of having done so without actually suffering through it.

1 COMPLETE DRAWING
Make sure the feathers are mapped out accurately.

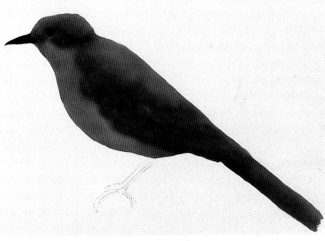

2 AIRBRUSH IN THE BASE COLORS
After the drawing is complete, erase it partially so that it is still visible but faint. You don't want too many pencil lines showing through the paint. Paint the base colors using an airbrush or a no. 6 bright. The reddish color is a mix of Naphthol Red and Hansa Orange; the dark color is a mix of Burnt Umber, Ultramarine Blue and a touch of Yellow Ochre.

Shade in the forms of the feathers with a dark Burnt Umber-Ultramarine mix. Use as small a flow as possible with the airbrush to get a tight line, outlining the feather shapes and shading them to give them form. You will be able to tighten up the edges by hand. You can mask each feather edge to make it sharp when you airbrush, but this isn't absolutely necessary.

MATERIALS LIST

paints
- Burnt Umber
- Ultramarine Blue
- Yellow Ochre
- Titanium White
- Naphthol Red
- Hansa Orange

brushes
- bright (synthetic): no. 6
- round sable (natural): no. 2

other
- airbrush

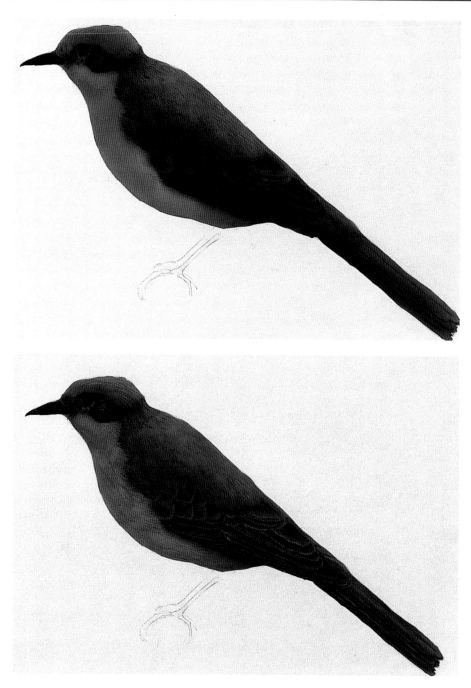

3 DEFINE THE FEATHERS

Darken the feather edges and sharpen things up with the same dark mix you used in the base color. Using the no. 2 sable, apply the dark shadow mix (Burnt Umber-Ultramarine Blue), defining the feather edges and bringing the image into sharper focus. Continue to shade the feathers, especially at the edges where an underlying feather appears darker than the one above it.

4 LIGHTEN EDGES, ADD HIGHLIGHTS

Mix Burnt Umber, some Yellow Ochre and Titanium White, and water this down to a washlike consistency. Use the no. 2 sable to lighten the edges of the feathers with tiny barbs. Where appropriate, add a highlight sheen to the feathers, drawing in the direction the barbs would naturally flow. Add highlights to the back feathers, trying to actually highlight between the dark lines you made earlier, giving volume to the feather barbs on the back and around the face. Highlight the red areas with a mix of Hansa Orange, Titanium White and a touch of Naphthol Red.

feathers on a little blue heron

1 ESTABLISH FORM AND PATTERN

Airbrush in the base color with the a mix of Ultramarine Blue, Titanium White and a touch of Naphthol Red.

Using a mixture of Ultramarine Blue with a touch of Naphthol Red, airbrush in the shadows. Make the bird darker than you think it should be, because later on you'll come back and add some lighter feathers on top of the darker color. The head and neck are more purplish than the body, so add extra red to the shadow mix when shading that area. Where appropriate, use the airbrush to sculpt individual feathers. Don't worry yet about keeping feather edges sharp—you can fix that later.

2 REDEFINE FEATHER EDGES AND BUILD HIGHLIGHTS

Using the shadow mixes, take a no. 3 sable and paint in more detail on the feathers. Deepen the shadow edges of the feathers and sculpt the forms of the thinner feathers. Mix the paint to an almost washlike consistency and build the shadows slowly and carefully. Keep it subtle.

Add Titanium White to the base mixes and build up the highlights with the no. 3 brush. Keep it a shade or two above your base color. Keep your paint thin, building highlights gradually.

Build on the darker lines you created with the shadow color and detail brush. Edge feathers where appropriate to sharpen edges.

3 FINISH HIGHLIGHTS

Mix more Titanium White with the base colors and add final highlights to the feathers. The feathers on the back have a bit of a sheen, so make them more "shiny" than others. The lighting determines how bright your highlights should be.

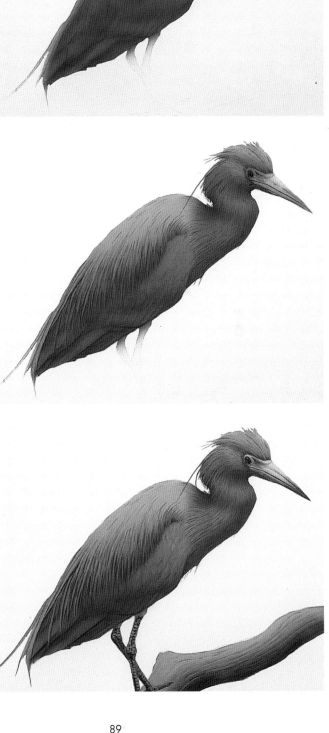

MATERIALS LIST

paints
- Ultramarine Blue
- Naphthol Red
- Titanium White

brushes
- round sable (natural): no. 3

other
- airbrush

89

turtle shell

Turtles have fascinating textures to paint in their shells, which range from the smooth, leathery softshell turtles to the hard, smooth sliders and the heavily textured tortoises. Color patterns range widely too, but most turtles have somewhat muted color on their carapace (the back, or top, of the shell). Painting turtles is not too difficult, but success requires the use of good references.

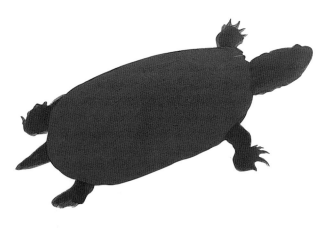

1 APPLY BASE COLOR

Draw the turtle on tracing paper and transfer the image to your painting surface. Be sure to include all the scutes (bony plates) visible on the shell in your drawing, but wait until you've painted in the base color before you add details that would be covered up. Mix Ultramarine Blue, Burnt Umber and Titanium White to make a middle-value base color. Paint in the turtle's form with a no. 6 bright. Do the edge details with a no. 3 round.

2 ADD DETAILS

Transfer the scutes and other details to the turtle form by covering the back of your drawing with chalk and then tracing over it onto your dry base color. Gently wipe off most of the chalk; enough should remain so that your drawing is still visible. Then add some Titanium White to the base color and paint in the lines between the scutes. If you are doing a species with a color pattern in the shell, this is where you would add the color: It needs to go on before the highlights and shadows.

MATERIALS LIST

paints
• Ultramarine Blue
• Burnt Umber
• Cadmium Red
• Cadmium Yellow
• Titanium White

brushes
• bright (synthetic):
 no. 6
• round: (synthetic)
 no. 3

other
• airbrush
• tracing paper
• chalk

3 ADD SHADOWS AND HIGHLIGHTS
Mix a dark for shadows from Ultramarine Blue and Burnt Umber (no Titanium White this time). Mask the edges of the turtle, thin the shadow mix for the airbrush and spray in the dark shading. Then mix a highlight color from Titanium White and Ultramarine Blue and spray it on, forming the mid-range highlights.

Use Cadmium Red and Ultramarine Blue for the red markings on the turtle, and Cadmium Yellow for the yellow markings.

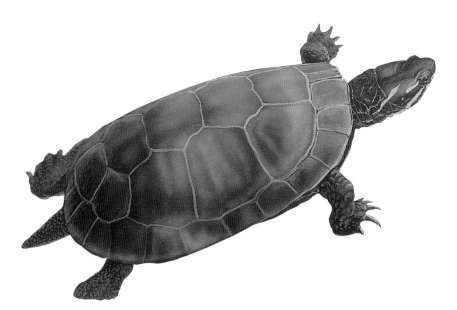

4 ADD BRIGHT HIGHLIGHTS
Mix your highlights from Titanium White and Ultramarine Blue. Thin this mix to a watery consistency and then use the no. 3 round to apply the lightest highlights. Load the brush with the watery mix and then squeeze most of the paint out so you can use a drybrush technique. Be careful to make the application smooth, smearing the paint out with your finger where necessary.

incidental animals

Adding extra animals can also add interesting subplots to your composition. Insects, frogs, rodents and other small creatures hiding in the nooks and crannies of the environment you've created make it more like the real thing. Insects are ubiquitous in the environment, and always add an interesting element to a scene. Sometimes these animals offer the possibility of interacting with your subject animal, creating tension in the scene, which makes the painting that much more interesting to the viewer.

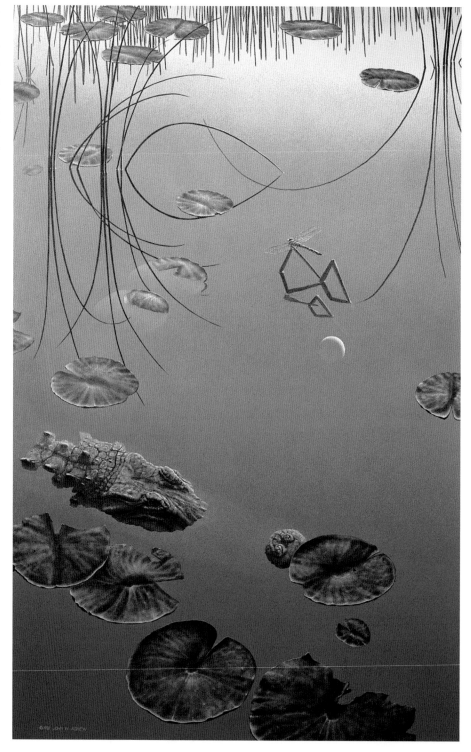

Here the dragonfly *almost* becomes a major element in the composition, but because of its minute size, it really is an incidental. The alligator dominates the scene, but the dragonfly adds another point of interest.

Alligator Moon
30" x 20" (76cm x 51cm)
Acrylic on illustration board

The footprints left by a passing animal can offer a fascinating subplot to your painting's composition. Animal tracks are a moment frozen in time and tell a story to those who are interested enough to read it.

Any time you see tracks in loosely consolidated sediments such as mud, dry sand or snow, the print will make a rim around the track itself (above, right). As the foot displaces the sediment, it squishes out to the sides.

When a track is left in more solid sediment, such as soft dirt, wet snow or firm mud, it simply leaves a depression, packing the sediment down (above, left).

Strombus
30" x 20" (76cm x 51cm)
Colored ink

putting it all together

In this chapter we'll take what we've learned so far and find an image, "collect" it, compose it into an interesting scene and execute the painting. Of course it isn't possible to use every technique we've discussed, but this painting covers the basics.

The idea of the painting in this chapter is to create a secretive feel in an intimate scene of two small lizards on an old ruin of a barn. The pattern of the boards, the textures of the weathered wood and lizards, the incidental details such as water drops and insects and the shadowy lighting all contribute to the effect. Let's take a look at how it all came together.

painting a piece of nature

The textures of old barn wood and lizards and the cracks between the boards in this demonstration make an interesting abstract pattern. Ruins such as this dilapidated barn make a true back-to-nature scene, as plants begin to consume man's handiwork and animals turn it into their habitat.

Reference Photo of Lizard

Reference Photo of Lizard

Reference Photo of Weathered Barn Siding

Thumbnail Sketch

1 COMPLETE THE SKETCH
Once you have a good idea of what to do, sketch it right on your surface.

2 EMPHASIZE CRACKS IN THE WOOD
Use Ivory Black and your no. 4 round sable to trace over the sketched areas that represent cracks in the barn wood so that the lines will be visible as you progress and cover the surface with several coats of paint.

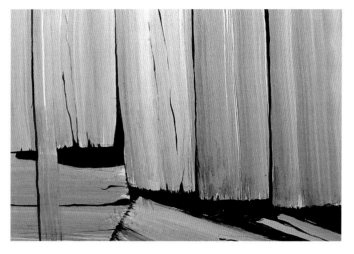

3 START PAINTING THE WOOD TEXTURE
Mix a wood color from Burnt Umber, Raw Sienna and Ultramarine Blue. Thin it to a wash and use a natural sponge to coat the entire board with this base color, using vertical strokes that follow the direction of the wood grain. On horizontal boards, use horizontal strokes. Let this base color dry.

4 BUILD THE WOOD TEXTURE
Add more texture to the wood with a sponge, applying the same base color with a dabbing motion. (See page 48 for more on this technique.)

If you want to keep the texture subtle, go over the sponge work a few times before it dries with a clean, damp sponge, calming down the texture a little.

5 ADD COLOR TO THE WOOD
The wood needs some extra color, so make one wash from straight Raw Sienna and another wash from Ultramarine Blue and Burnt Umber. Apply these in wide streaks with a no. 10 bright. You may also choose to darken the wood with the Ultramarine Blue-Burnt Umber mix. Let this coat dry.

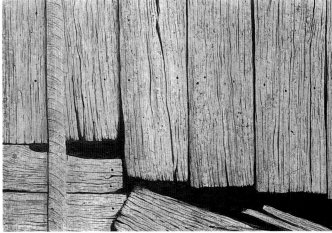

6 ADD GRAIN TO THE WOOD

Use a natural-bristle fan brush and some very thin Ivory Black paint and lightly drag the brush over the boards to create wood grain. Wood grain is rarely very straight, so it's good to put a little waviness into the lines, working in the occasional knot with a twist of the brush.

If you need to build the grain up more, use a tiny no. 4 round sable to add some deeper lines, a little texture and the occasional nick or scratch.

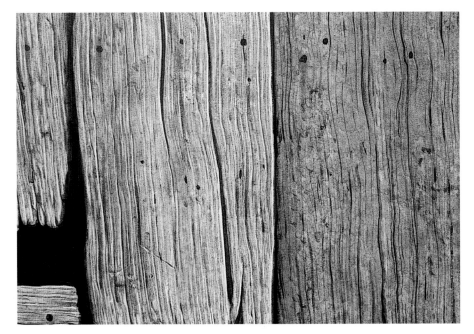

7 HIGHLIGHT THE GRAIN

Mix a little Raw Sienna and Titanium White to the base wood color of step 3 and use it to build up the wood texture with your no. 3 round sable.

Heavily weathered wood has grain that stands out very strongly. In this situation, where the light is shining at an angle across the wood, it stands out in bold relief. Applying the highlight color between the black lines of grain makes the wood surface look three-dimensional. Where the lines of grain have a little distance between them, make sure to apply the highlight color at the left edge of the black lines, just where the light would catch the edge of the wood grain.

Add details such as rust streaks with Red Oxide.

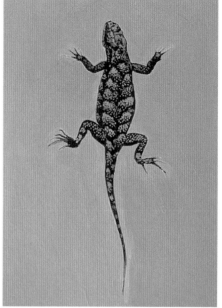

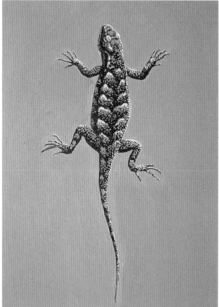

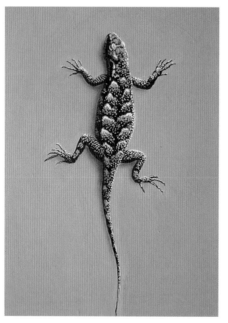

8 ADD LIFE

Once the wood is complete, add the lizards. Transfer them from a sketch to the painting, using chalk on tracing paper. Paint in the lizards as black silhouettes.

Build up their patterns with gradually brighter colors. These Fence Swifts are primarily gray and white, with tints of Raw Sienna and Yellow Ochre.

When they are complete, airbrush in their shadows with a mixture of Ultramarine Blue and Ivory Black, thinned and strained for the airbrush. You do not have to mask the body of the lizard before airbrushing the shadow because you can shade the body at the same time.

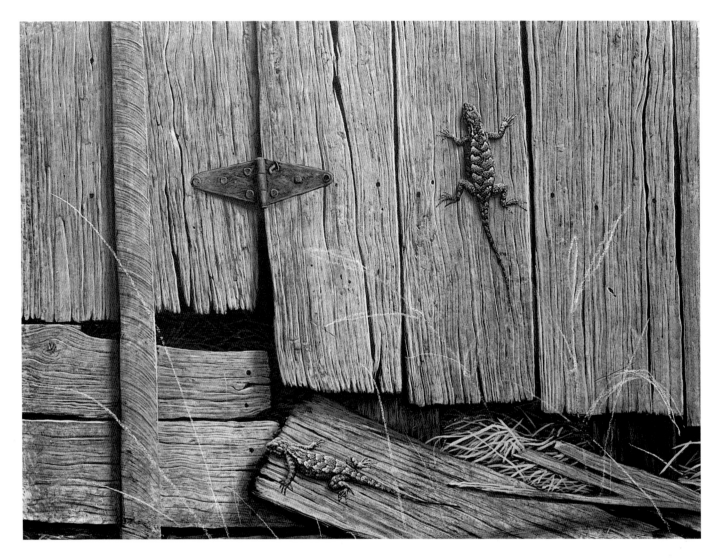

9 ADD DEPTH TO THE BARN SIDE
Inside the spaces between the boards, add some old straw to give some depth to these dark spots. Start with Raw Sienna and Ivory Black, painting in the straw with a no. 4 bright. Build up the straw with increasing amounts of Yellow Ochre and Titanium White as it becomes more brightly lit near the openings. Sketch in grasses and chicory with chalk.

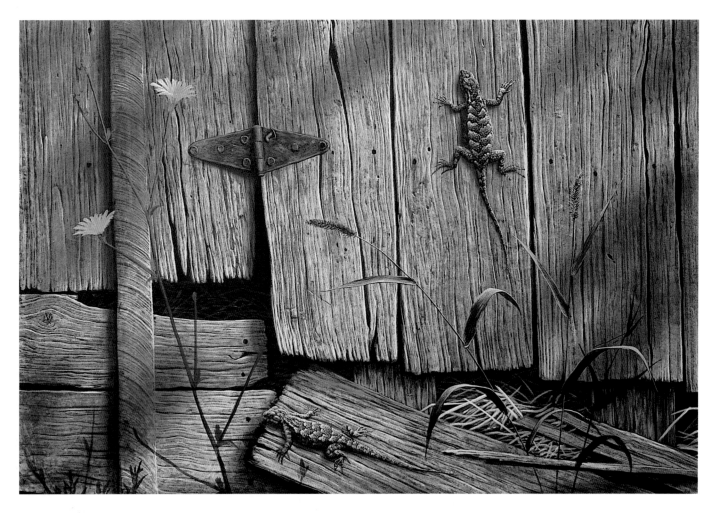

10 ADD FOLIAGE, FLOWERS AND SHADOWS

Paint the basic shapes of the foliage in a dark green made of Hooker's Green and Ivory Black with the no. 4 bright and the no. 4 round sable. Let it dry. Highlight the stems and leaves with a mixture of Hooker's Green, Yellow Oxide and Titanium White. Where the light shines through the grass leaves, mix Cadmium Yellow Light with Hooker's Green to create the look of sunlight passing through the leaf. Add the brightest highlights by adding more Titanium White and a little Cadmium Yellow.

Paint in the blossoms with a mix of Dioxazine Purple and Ultramarine Blue, plus some Titanium White, using your no. 4 bright and no. 4 round sable.

To break up the flat surface of the boards and add a little mood to the scene, add some leaf shadows on the barn wood. Sketch the shadow shapes in with chalk and then lightly airbrush the shapes of shadows onto the boards. Mix the shadow color from Ivory Black and Ultramarine Blue, thin it and strain it for the airbrush. Wipe the chalk away and finish the shadow forms. (It is important not to do heavy airbrushing directly over a chalk sketch. The chalk can act like masking and leave a light streak when you wipe it off. Or, if you spray heavily, it can be wetted by the paint, making it permanent.) This composition has a nice "secret" feel to it, helped along by the shadows on the barn wood. Without the shadows, it might feel a little too out in the open. The shadows suggest a scene partially hidden by overhanging leaves.

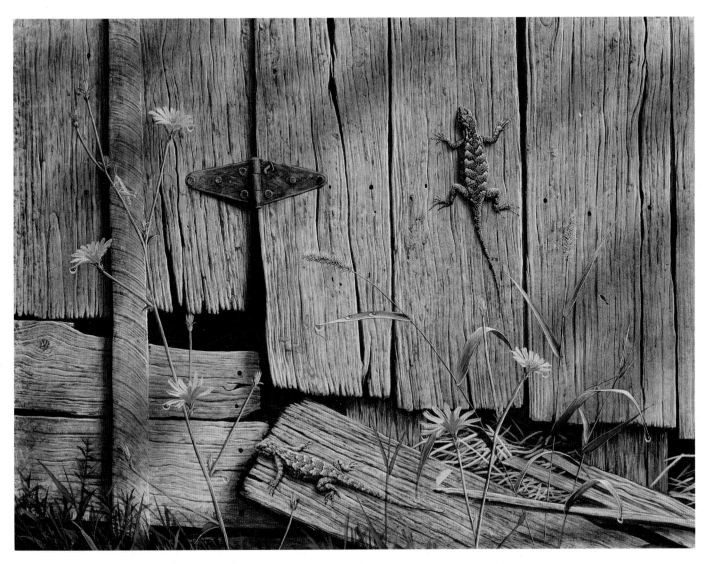

11 ADD FINAL TOUCHES

Add a few more items of interest. Try adding a grasshopper on a stem and some water drops on the plants to suggest a storm that may have passed by recently. These items add a great deal to the story in the painting. The grasshoppers could be potential prey for the lizards, adding a subtle tension to the scene.

Drying Out
15" x 20" (38cm x 51cm)
Acrylic on illustration board

chapter 6

painting murals

Murals may seem like to grand a way to portray the "secret" world of nature, but in a museum or zoo setting they often depict places and animals that are not otherwise visible. They may portray extinct animals or places not accessible to humans.

Murals have been done on the walls of buildings since ancient times and are still popular today on public buildings, in museums and in private homes. Their large size is intimidating to some artists, but it can be a great opportunity to create art that is larger than life.

materials and setup

paint

For *indoor murals*, acrylics or acrylic-latex-based paints are preferable because they dry quickly and have a great flexibility. This is important in very large paintings because walls move with changes in temperature and with the settling of buildings. Also, acrylic paints do not generate unhealthy fumes, and they clean up with soap and water. For *outdoor murals*, masonry paints with a latex or acrylic base are best.

Zoo exhibits present the toughest environments for murals to survive. Inside an animal cage, the paints must survive the ravages of urine and other animal wastes, as well as daily washings by animal keepers. Some animals will scratch or pick at murals. In these situations it is critical that walls are prepared carefully.

brushes

Painting a mural does not require brush types other than what you normally use for small paintings, plus a few large brushes for laying in large areas of underpainting or skies. Rollers and large flat brushes that you would use in house painting and large spray guns all help to cover wide areas quickly. Pick several natural sponges of different textures to use for doing textures such as rock, bark and moss.

If you are using a large spray gun or "detail gun" (like a small spray gun), you will need a more substantial air compressor than the small one normally used for airbrushes. Use a compressor with a minimum of a 2hp motor, a pressure tank, a pressure regulator and a moisture trap. To run a large spray gun, the air output should be at least 50cfm (cubic feet per minute) at pressures of at least 80psi (pounds per square inch). A large compressor like this can also be used for a small airbrush, with the pressure adjusted according to the airbrush manufacturer's instructions. You will probably need an adapter to fit the airbrush's small screwtype air hose connector to the snap-on hose of the larger compressor.

helpful tools

A *long lightweight pole* with a piece of charcoal (or chalk if you're working on a dark surface) comes in handy when sketching in your mural on the wall. It not only gives you a longer reach, but also lets you view your work at a distance.

If you are working at a very large scale, you can have an assistant on the scaffold or mechanical lift with the charcoal follow along as you use a *laser pointer* to "sketch" in the mural. This laser technique is also useful when constructing a precise perspective. It is usually necessary to stand where the painting will be viewed from in order to sketch the proper perspective. If your sketch pole won't reach far enough, use the laser and a friend.

preparing outdoor or exhibit walls

Your walls must have a water-resistant construction that will not allow water to come from behind and lift the paint off the surface. Plaster of Paris and wood are not compatible with zoo-cage mural walls, although they will work fine in a museum or other indoor setting. Cement plaster (a fine-grained concrete) over a metal lath makes the best surface in a wet environment. If you need to smooth out cracks and holes before painting, use a water-resistant material such as an acrylic modeling paste. Prime it with a penetrating layer of thin paint.

After the mural is completed, a waterproof concrete sealer should be applied to help protect the paint surface from repeated washings. Remember that all walls will crack eventually, so do not rely on sealer alone to protect your mural.

preparing indoor walls

When preparing a wall for an indoor or protected area where you do not expect weather or water to be a problem, waterproof construction and preparation is not so critical: Prepare the wall the same way you would for any other painting project. Make sure the wall is clean and free of dust or grease. New plaster, drywall or cement should be painted with a primer or sealer first, and can then be primed with ordinary white latex house paint.

protecting your mural

After the mural is finished, it should be coated with a sealer to protect the painting from abrasion and cleaning. For outdoor or exhibit murals, a concrete sealer such as Hydrozo should be applied to protect the paint surface from the weather or repeated washings. Before applying a sealer, make sure it's compatible with your paint.

For indoor murals protection is not as critical, but can help the mural last longer. An acrylic varnish or medium works fine in most situations, but will not withstand much abuse and can turn milky if exposed to repeated washings. If you expect your mural to be touched frequently, a more substantial sealer may be warranted. One of the best products for this is a furniture finish called Polycrylic, made by Minwax. This is an acrylic, water based substitute for urethane furniture varnish, available in hardware and paint stores. It produces a hard, clear finish that is very washable. In most situations it is best to use a satin finish varnish because a gloss finish can create problems with glare. Application can be done with a brush or spray gun, but remember to follow the manufacturer's instructions. Thinning excessively with water can make the varnish turn milky.

lighting

It is very important to paint your mural under the same lighting conditions under which it will be viewed. If you are doing it in place this shouldn't be a problem. However, I have painted murals in exhibits under construction in which the final lighting was not yet installed. This can lead to unpleasant surprises. Unanticipated shadows or glare can ruin a wonderful painting. The color of the light, such as incandescent or fluorescent, should be determined so that you paint under the same light color. If you paint under fluorescent light and the painting is displayed under incandescent light, the colors can change in significant ways.

getting up there

Access to tall murals always presents a problem. Ladders are uncomfortable and dangerous to work from, but are sometimes the only solution. Scaffolding is stable and cheap, but blocks your view of your work. A mechanical lift such as a "cherry picker" is great if you or the client can afford to rent one, but they are difficult to maneuver on uneven surfaces and in tight spots.

Mechanical Lift

Scaffolding

painting an ancient landscape

Recreating ancient animals requires a lot of research into animal remains and how to reconstruct them into a good guess of what the living animal looked like.

The same is true for ancient landscapes and plants, although there are living examples of most plants found in the fossil record.

1 START SMALL

It is best to create a scale model of the wall or exhibit where the mural is to be painted, and design the painting at that small scale. Use a 1"–1' (2.5cm–30.5cm) scale (but you can do your model painting at any scale) and draw or paint the mural at the 1" (2.5cm) scale, refining the composition there.

2 TRANSFER YOUR SKETCH TO THE WALL

Construct a grid of lines 1" (2.5cm) apart on the scale drawing (or photocopy of the scale painting). When the wall is prepped and ready for painting (see page 106), draw a 1' (30.5cm) grid on the wall using a measuring tape and carpenter's chalk. The grid acts as a guide as you sketch out the painting on the wall. This resolves the problem of keeping a large image in the proper proportions as you work.

MATERIALS LIST

paints
- Phthalocyanine Blue
- Ultramarine Blue
- Burnt Umber
- Yellow Ochre
- Cadmium Yellow
- Cadmium Orange
- Hooker's Green
- Phthalocyanine Green
- Acra Violet
- Titanium White

brushes
- flat: 4-inch (102mm)
- brights: no.s 4–10,
- rounds: no.s 3–6

other
- airbrush
- rollers
- large airgun (large paint sprayer)
- small airgun (detail paint sprayer)
- natural sponges
- sketch pole
- laser pointer
- charcoal
- chalk
- latex mold rubber or other frisket

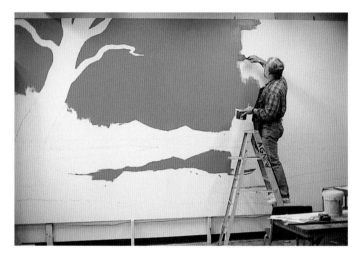

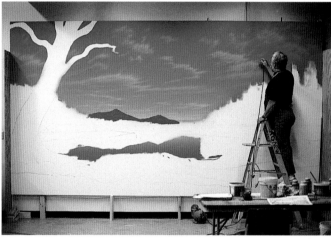

3 LAY BASE COLOR IN THE SKY AND ITS REFLECTION

This early-morning scene has a clear blue sky with high cirrus clouds and mist rising from the lake. The sky's base color here is a mix of Phthalocyanine Blue, Ultramarine Blue, Titanium White and Yellow Ochre. Go easy on the ochre—its main purpose is to tone down the blue. If you use too much, the sky will go green. Apply the base color to the sky area with a large brush, roller or large airgun.

Perspective

When you stand outside and look out at a landscape, the true horizon always appears to be at eye level. It doesn't matter if you are standing on a mountaintop or the beach, the horizon will always appear to be level with your eyes. You must recreate this in your mural to make a believable landscape.

Since everyone is not the same height, you'll have to compromise. A rule of thumb is to make 5' 4" (163cm) the level of the horizon. This is considered to be the average height of most people's eyes. Make sure that this will be measured from the floor to the horizon in your painting.

4 ADD ATMOSPHERE TO THE SKY AND REFLECTION

When you look at a clear sky, it is darkest blue directly overhead and lightens in color as you look closer to the horizon. This effect is caused by water vapor, dust and smoke in the air.

Add some of the base color to Ultramarine Blue and thin it enough to use in an airbrush or small airgun (a paint sprayer that is somewhere between an airbrush and a large airgun). With the darker blue mix, darken the sky from the top of the canvas to about one-third of the way to the horizon. Then, from the horizon up to a third of the way toward the top, fade in a layer of Titanium White and Yellow Ochre, mixed thoroughly and thinned and strained for the airbrush.

When mixing cloud colors, a good basic mix for white clouds is Titanium White with a touch of Yellow Ochre. Be sure to mix it thoroughly and to strain it for the airbrush.

Paint in the distant mountains with a mixture of Ultramarine Blue and Burnt Umber.

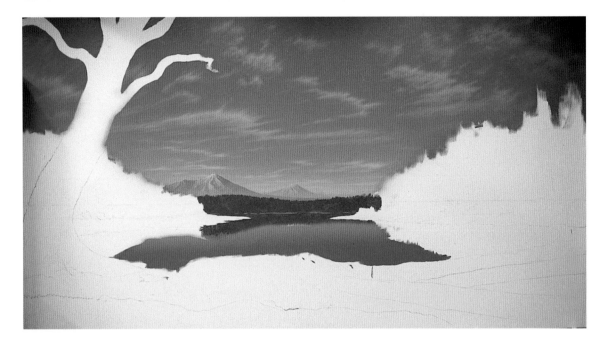

5 CONTINUE THE DISTANT LANDSCAPE

Complete the sunlit texture on the mountains with Cadmium Orange plus Titanium White and Cadmium Yellow. When it is dry, airbrush on a layer of haze.

Lay in the base coat for the distant trees.

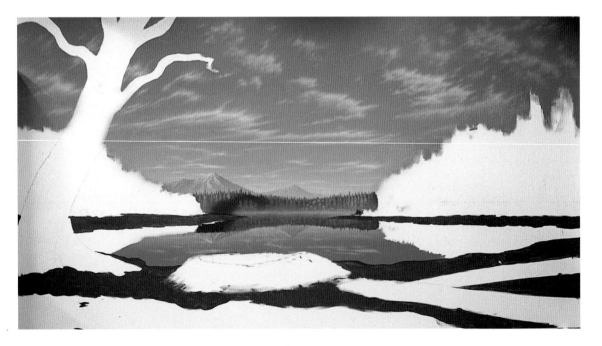

6 DETAIL DISTANT TREES AND START FOREGROUND

Working from the most distant elements to the foreground, add trees and other parts of the landscape using colors mixed with Hooker's Green, Phthalocyanine Green and Acra Violet.

7 ADD MIDDLEGROUND TREES AND REFLECTION

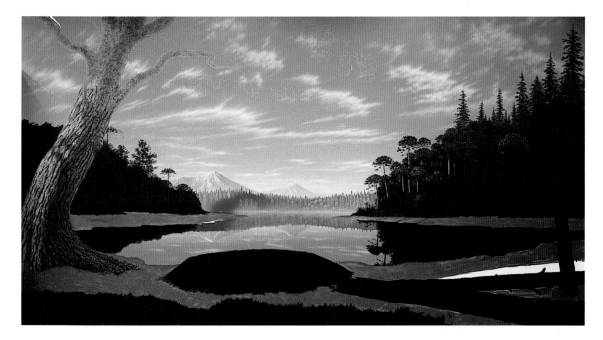

8 ADD AND DETAIL FOREGROUND AND TREE

The object here was to create a mysterious jungle ruin for the monkeys to inhabit. The cage has a concrete reconstruction of a portion of the ruins, and the purpose of the mural, as in most zoo exhibits, was to make the cage look much bigger by extending the three-dimensional construction onto the two-dimensional walls. Another purpose of zoo murals is to represent the habitat in more detail than is possible in the three-dimensional construction. The visitor has the feeling of being an explorer in a remote jungle site. The mist airbrushed into the scene blended perfectly with the fog-generating apparatus inside the cage.

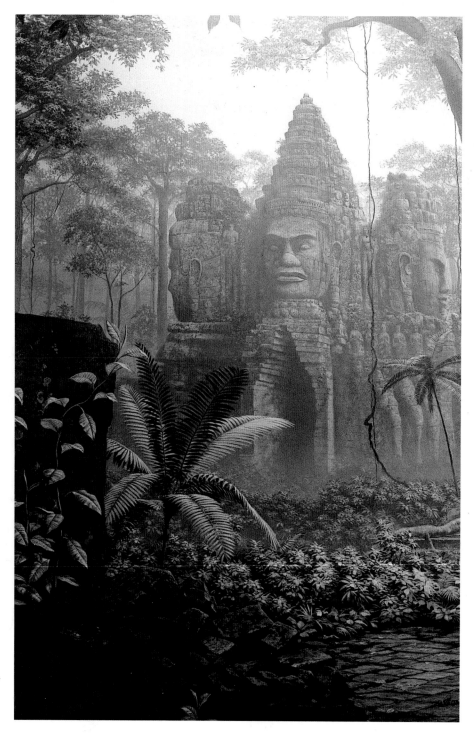

Angkor Wat Mural (detail)
Langur monkey cage, Cincinnati Zoo
Detail shown is approximately 12' x 8' (3.7m x 2.5m)
Acrylic on cement plaster

Another section of the same Langur monkey cage shows how the jungle creeps over the ruin, enveloping it and turning man's handiwork into just another piece of habitat. The pattern of stone pavers at the bottom of the mural had to blend perfectly with similar three-dimensional construction in the cage. To do this convincingly meant that I had to sketch the pattern from outside the cage with a long pole tipped with chalk to achieve the correct perspective.

Angkor Wat Mural (detail)
Langur monkey cage, Cincinnati Zoo
Detail shown is approximately 12' x 8' (3.7m x 2.5m)
Acrylic on cement plaster

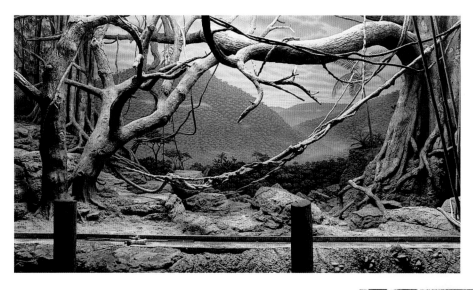

This zoo cage emulates the classic museum diorama, but with live animals rather than stuffed ones. Exhibits like this let the visitor experience an animal in its natural habitat. Here you can see the concrete trees and artificial vines that must be blended into the painting in the background.

Diana Monkey Cage Mural (detail)
Cincinnati Zoo
Detail shown is approximately 16' x 30'
(5m x 10.9m)
Acrylic on cement plaster

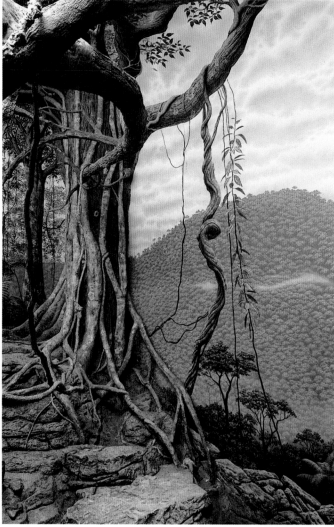

A concrete tree was built directly on the wall with the mural. To make the painted branches and vines appear to be as real as the concrete tree, it was necessary to make the painted elements contrast strongly with the background.

Diana Monkey Cage Mural (detail)
Cincinnati Zoo
Detail shown is approximately 16' x 10' (5m x 3.1m)
Acrylic on cement plaster

Recreating an ancient glacier and blending it with artificial ice was a real challenge. The most difficult part of tying in a painted mural with a 3-D foreground construction is the fact that light falls more directly on the 3-D foreground than it does on the vertical wall surface. Often the painting has to be painted much brighter than the objects in front of it in order to appear to be the same. Sometimes it is just not possible to make the painting any brighter. In this case you may need to darken the foreground objects, either by putting more light on the mural and less on the foreground or by actually darkening the foreground with an airbrush and dark paint.

Ice Age Mural (detail)
Cincinnati Museum of Natural History
Detail shown is approximately 8' x 6' (2.5m x 1.8m)
Acrylic on cement plaster

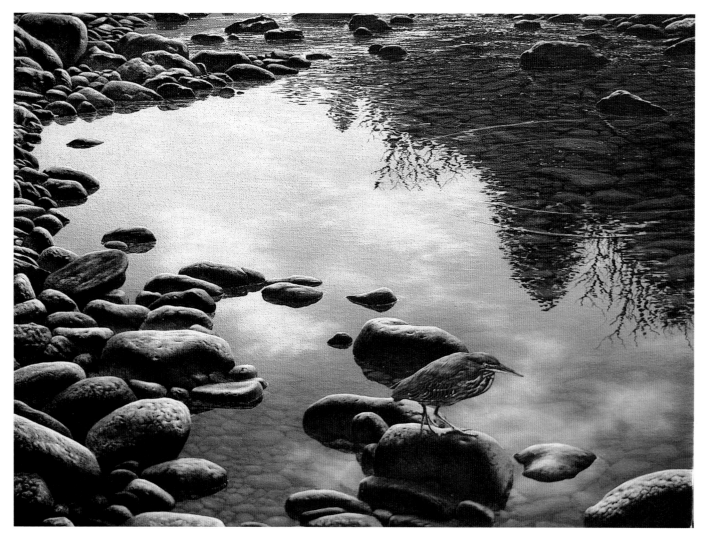

The Minnow Pool
(Green-Backed Heron)
17" x 23" (43cm x 58cm)
Acrylic on canvas

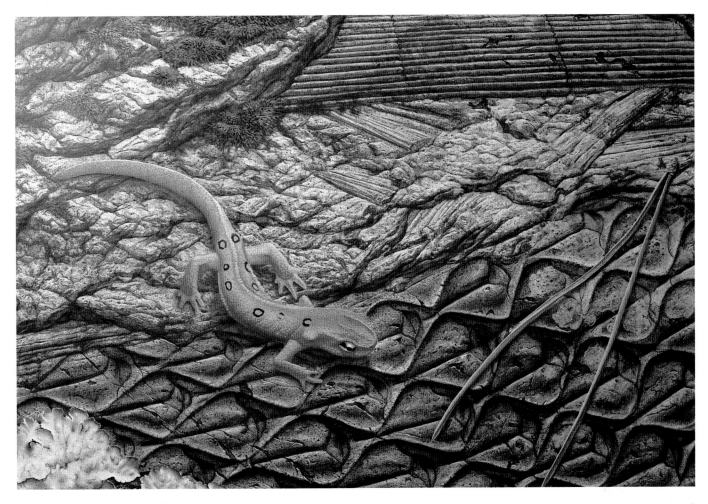

A Walk Across Time
(Red eft on plant fossils)
32" x 48" (81cm x 122cm)
Acrylic on canvas

The Beacon
11" x 24" (28cm x 61cm)
Acrylic on illustration board

**The Resplendent
Quetzal**
32" x 24" (83cm x 61cm)
Acrylic on canvas

Actun Xpukil, Cave of the Mice
32" x 24" (83cm x 61cm)
Acrylic on canvas

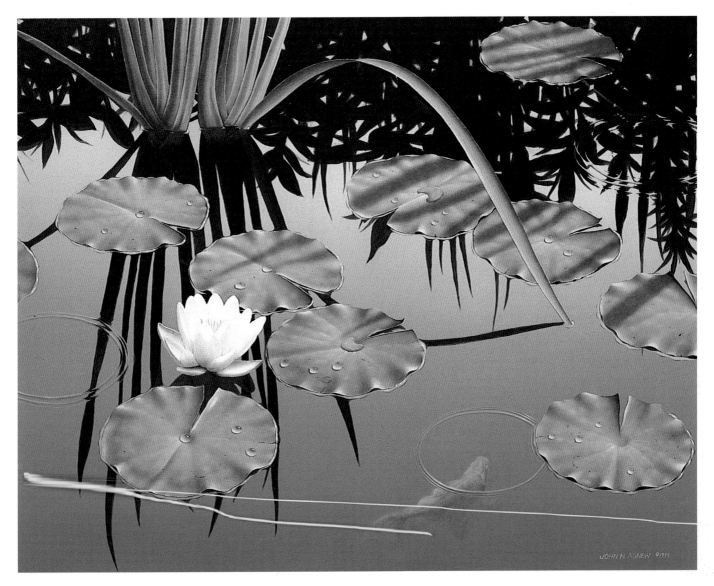

Garden Pond
24" x 32" (61cm x 81cm)
Acrylic on canvas

© JOHN AGNEW 1981

In this book we've explored many of the routes to a successful painting: how to find images, how to compose them into an interesting scene and how to execute the details of the painting itself. But it's not just these elements alone that will guarantee success in your art, it's the combination of technical skill and imagination. Your imagination is the one element that makes a painting a piece of art. You, as the artist, have to be emotionally motivated to produce the piece. It takes determination to do hours of tedious detail work, but your emotional involvement in the painting is the source of that determination.

Just as a writer must "find his voice," an artist must find his vision. What is your "vision?" Simply said, it's the way you look at things. Maybe you're fascinated by the textures of animals or their environment. Maybe you like to tell visual stories of animal interactions. Whatever it is that turns you on in the world of nature should be what you are interpreting through your art. If you aren't sure what that is, you need to spend more time out there looking.

My paintings almost always arise from some experience I had outdoors. People sometimes ask why I can't just invent images in my mind or find inspiration in a magazine or book. For me, that just doesn't work. I need that personal involvement, a connection between myself and the subject matter through a personal experience.

Just as you need to experience nature in order to find subject matter, you need to experience the art of others to develop a way to see. To develop a "feel" for composition requires looking at thousands of images. Eventually you get used to seeing what works and what doesn't, and good compositional skills become instinctual. You also learn how to avoid visual clichés. Combine this with your vision, and you're on your way. It may take years of practice to develop the technical skills, but stick with it and keep your vision in your mind, and the successful paintings will come.

How do you evaluate the success of your paintings? It's difficult for you to do this by yourself. You can judge how well you followed the rules of composition or how good your technique is, but ultimately it's how other people react to it that tells you how successful it is. A painting is a form of communication, and if the message doesn't get across, it hasn't succeeded. On the other hand, the reward is great when you do succeed and people tell you honestly how much they like it. Of course, a purchase is the ultimate compliment.

I sometimes joke with people that being an artist beats working for a living, but it actually is a lot of hard work. The difference is that I love what I do. It is the ultimate satisfaction with one's work to come to the end of a long, hard day and have something beautiful to show for your effort, and to be able to share that with others. In addition, I get to do a lot of what I love most, being outdoors just looking at, and admiring, nature. As long as you can do what you love, the rest should come naturally. Just keep doing it.

Yucatecan Tree Snail
20" x 15" (51cm x 38cm)
Acrylic on illustration board

index

capture nature's magic with North Light Books!

Through step-by-step demonstrations and magnificent paintings, Patrick Seslar reveals how to turn oils, watercolors, acrylics or pastels into creatures with fur, feathers or scales. You'll find instructions for using light and color, researching your subjects and their natural habitats, and capturing realistic animal textures.

1-58180-086-X, paperback, 144 pages

This extraordinary reference provides a wealth of gorgeous, crisp photos that you'll refer to for years to come. Finding the right image is easy—each bird is shown from a variety of perspectives, revealing their unique forms and characteristics, including wing, feather, claw and beak details. Four painting demos illustrate how to use these photos to create your own compositions.

0-89134-859-X, hardcover, 144 pages

Capture your favorite animals up close and personal—including bears, wolves, jaguar, elk, white-tailed deer, foxes, chipmunks, eagles and more! Kalon Baughan and Bart Rulon show you how, providing invaluable advice for painting realistic anatomies, colors, and textures in 18 step-by-step demos.

0-89134-962-6, hardcover, 128 pages

Make your wildlife paintings stand apart from the herd by capturing the fine details that give your subjects that certain "spark" they need to come to life. Fifty step-by-step demonstrations show you how to make fur look thick, give feathers sheen, create the roughness of antlers and more!

1-58180-177-7, paperback, 144 pages

Inside this incredible reference you'll find more than 1,000 definitions and descriptions—every art term, technique and material used by the practicing artist. Packed with hundreds of photos, paintings, mini-demos, black & white diagrams and drawings, it's the most comprehensive and visually explicit artist's reference available.

1-58180-023-1, paperback, 488 pages